MICHAEL FREEMAN'S
PHOTO SCHOOL
DIGITAL EDITING

MICHAEL FREEMAN'S
PHOTO SCHOOL
DIGITAL EDITING

EDITOR-IN-CHIEF **MICHAEL FREEMAN**
WITH **STEVE LUCK**

ILEX

First published in the UK in 2012 by

I L E X

210 High Street
Lewes
East Sussex BN7 2NS
www.ilex-press.com

Copyright © 2012 The Ilex Press Ltd

Publisher: Alastair Campbell
Associate Publisher: Adam Juniper
Creative Director: James Hollywell
Managing Editor: Natalia Price-Cabrera
Specialist Editor: Frank Gallaugher
Editor: Tara Gallagher
Senior Designer: Kate Haynes
Designer: Lisa McCormick
Colour Origination: Ivy Press Reprographics

British Library Cataloguing-in-Publication Data
A catalogue record for this book is available
from the British Library

ISBN: 978-1-908150-31-8

Printed and bound in China

10 9 8 7 6 5 4 3 2 1

Photo on page 2 © Samir Khadem
Photo on page 4 © Jaroslaw Grudzinski
All other photography © Michael Freeman
unless otherwise noted.

Contents

FOREWORD

About This Series

Photography is what I do and have done for most of my life, and like any professional, I work at it, trying to improve my skills and my ideas. I actually enjoy sharing all of this, because I love photography and want as many people as possible to do it—but do it well. This includes learning why good photographs work and where they fit in the history of the craft.

This series of books is inspired by the structure of a college course, and of the benefits of a collective learning environment. Here, we're setting out to teach the fundamentals of photography in a foundational course, before moving on to teach specialist areas—much as a student would study a set first-year course before moving on to studying elective subjects of their own choosing.

The goal of these books is not only to instruct and educate, but also to motivate and inspire. Toward that end, many of the topics will be punctuated by a challenge to get out and shoot under a specific scenario, demonstrating and practicing the skills that were covered in the preceding sections. Further, we feature the work of several real-life photography students as they respond to these challenges themselves. As they discuss and I review their work, we hope to make the material all the more approachable and achievable.

For you, the reader, this series provides, I hope, a thorough education in photography, not just allowing you to shoot better pictures, but also to gain the same in-depth knowledge that degree students and professionals do, and all achieved through exercises that are at the same time fun and educational. That is why we've also built a website for this series, to which I encourage you to post your responses to the shooting challenges for feedback from your peers. You'll find the website at **www.mfphotoschool.com**

Student Profiles

Guido Jeurissen

Born on the 19th of August, 1992, in Rotterdam, Holland, Guido Jeurissen is a young and learning photographer, filmmaker and musician. Even though Guido Jeurissen's work is a combination of a very wide range of styles, his personal style is often defined as "raw" and "documentary."

When Guido was admitted in 2010 to the Dutch art school Willem de Kooning Academie in Rotterdam, he started a study on filmmaking called Audio Visual Design. Even though his study is primarily based on filmmaking, he also learned a lot about photography.

Recently, Guido has been focusing much more on photography. He went back to the basics, and started working in dark rooms with black-and-white film. It's here where he noticed that the essence of photography is in the subject and not the picture itself. Black and white was the ultimate tool to do this. He loves the way analog black-and-white photography concentrates on the subject so much more, and how the background of an image is so much less distracting.

Black and white, however, is not the only thing for him. Guido has never forgotten about how color can make an image very powerful. The saturation of some colors can strengthen the image a lot—which he has been exploring with software like Adobe Photoshop and Adobe Lightroom.

Guido's creative mind is best shown in his videos, which can sometimes be absurd and surrealistic. His work has been exhibited at the International Film Festival Rotterdam (IFFR), Stukfest Festival Rotterdam, ASVOFF fashion Film Festival in Barcelona, and has been published on various websites.

For more about Guido's work, please visit www.guidojeurissen.com

You can contact Guido at guidojeurissen@gmail.com

Faith Kashefska-Lefever

On top of being a mother and a wife, Faith is a freelance photographer and photo restorer, and very passionate about both. Her restoration work includes repairing and coloring old photographs. "It is my way of helping old memories stay alive, and preserving pieces of family history," she says. "I love to use my photography as a way to show a different point of view, as well as to show the beauty in everything and everyone. I am always asking, 'If a photo is worth a thousand words, what would you like yours to say?'"

Faith's education comes from two places: NYIP (New York Institute of Photography) and herself. If she is not snapping pictures or working on a restoration, she usually has her face in a book learning something new. All of her post-processing and digital manipulation is self taught.

To see more of Faith's work, check out www.fklgz.com

Dan Goetsch

Dan Goetsch was born and raised in Fort Collins, Colorado. He eventually ended up hitting the ground running in the IT world just after college and life has been an adventure ever since. Through his work, Dan has had the opportunity to do a good amount of travel, which led him to relocate to the west coast. He found his new home in Portland, Oregon where he spent 5 years, and picked up his first digital SLR camera along with a passion for photography. He is a self-taught photographer who has gone from Auto mode to Manual and enjoyed every minute of the journey as he continues to learn and explore the craft. His superhero mantra would be "IT nerd by day, photographer by nights and weekends."

After living in the Pacific Northwest for a while, he eventually grew homesick and took an opportunity to relocate back to Colorado where he currently resides. He always looks for an opportunity to learn something new about the trade, and is always looking for a challenge.

Dan's passion for photography continues to grow stronger every day, and he looks forward to sharing his love of it with the world.

You can see his work at www.danielgphotography.com

Johnny Chang

Johnny's love of photography was born out of his penchant for observation: from watching busy executives scurrying about the office or ants raiding a fallen popsicle, to light shining through a dusty room. A camera in his hand, circa 2009, was a natural extension. It's brought him the joy of discovering new places and the hidden beauty of everything.

Never limited to a genre, Johnny's style is constantly evolving. He strives to see many different perspectives, from high to low, without fear of being stepped on in the process. One constant is his fascination with light: from its role in perceptions to its duality in physics. Johnny takes advantage of light and how it can reveal, yet at the same time deceive and mystify. To him, it is a valuable tool in crafting a visual journey. His inquisitive nature enables an intricate relationship with the inner workings of the camera, the lens, and the light. When his interest is piqued,

he won't stop until he finds the right path—through a multitude of exposures, lighting manipulations, or processing directions.

When Johnny is not looking through a viewfinder, he is practicing electrical engineering near his hometown of Scaggsville, Maryland.

You can view more of his work at: http://eruditass-photography.blogspot. com

Introduction

Editing and post-production work is often a polarizing part of digital photography. Everyone has an opinion: Some say that any departure from a completely faithful and untouched reproduction of the original subject is fraudulent; others say the sky is the limit, and you can do whatever you like to any image. As usual, the truth lies somewhere in the middle.

For one, there is no such thing as a completely faithful reproduction—the process of capturing photons, converting them into digital information, and displaying that information in a two-dimensional format requires various levels of creative interpretation at several steps along the way. And on the other hand, the more digital enhancement that goes into an image—particularly as you begin introducing special effects and adding elements that weren't in the original scene at all, such as with composites—the closer you get to crossing a line between a photograph and a work of digital art.

This book will cover the space in between these extreme interpretations Starting with an overview of the image-editing programs available to today's photographer, we will spend two chapters thoroughly covering your various options for image optimization—and that word is used quite intentionally. Even in more creative and subjective techniques like black-and-white conversion, the methods covered concern themselves primarily with making the most out of the latent potential within each image. The final chapter, on the other hand, covers the more open-ended topics of digital editing, in which you'll be combining separate images into one composite, removing unwanted objects from the image, stitching together panoramas, and other techniques that delve deeper into the creative tools available in pixel-level editors.

Some of these techniques will resonate with your personal photographic style and workflow, other will likely not. However, for all the techniques discussed herein, whether or not you use them in your own photography is not nearly as important as the fact that you will be able to if needed or desired—that you recognize and are familiar with the various tools and

← Hide your work

This relatively straightforward landscape has, in fact, had the sky desaturated, the greens and yellows saturated individually, and the contrast reduced by a curves adjustment. And yet, the resulting image is more faithful to the original scene.

options available, so that you can make the right decisions for each image that crosses your desktop. That is also the idea behind the Challenges scattered throughout the book: They are not meant to necessarily convince you that, say, Curves is the best tool for adjusting your shadows and highlights, or that HDR is the only technique for dealing with high-contrast situations. Rather, they are meant to get you familiar with possible courses of action, and prepare you for the wide range of photographic possibilities that you will encounter.

→ **Clean representation**
Even completely "faithful" photographs like those used in art catalogs often require some degree of optimization in post-production.

Image Editors

Image editors have evolved greatly in recent times. In fact, you could argue that their development has in many respects overshadowed the advances made in digital camera technology over the same period. Certainly camera processing, design, and sensor technology have improved, but their evolution doesn't match the revolution that we've witnessed with imaging software in the last four or five years. In the past, Raw processors were simply a way of extracting and optimizing the unprocessed "raw" data from the camera, and preparing it for post-production work and output using software such as Photoshop or PaintShop Pro. Applications like Lightroom and Aperture, however—although they are as much about digital asset management and efficient workflow as they are Raw processing—have evolved their editing capabilities over time into the powerful editing tools we have today.

By the same token, the "traditional" post-production tools, such as Photoshop, Photoshop Elements, and PaintShop Pro have also evolved new skill sets. Raw processing is now much more integrated within such software, and most are also able to maintain libraries of images and prepare them for print or web output.

As with so many aspects of digital photography, there are no right or wrong tools for image editing, just many to choose from. This opening chapter will help you to select the right ones for you.

The Digital Workflow

Before we begin to look in detail at the tools and practices of digital photo editing, it's worth spending just a brief moment or two discussing the concept of the digital photography workflow, as this will help you see where image editing fits within the broad scheme of creating a digital image.

In the context of digital photography, "workflow" essentially describes the entire process of producing a digital image—from capture and importing, organizing and reviewing, through Raw processing and post-production, to distribution and backup. If you're unfamiliar with any of these terms: Capture essentially means the action of taking the photograph; importing is simply transferring the image files to the computer; organizing and reviewing involve creating appropriate folders, ranking, and making a selection of your images; Raw processing and post-production (often grouped together) are concerned with optimizing the image so that it looks as good as it possibly can; distribution is primarily about preparing the image for either print or viewing on-screen; and finally, backup refers to the process of safely archiving and storing your images. Although there's no single specific workflow for all photographs, there are definite considerations that must be taken before an image is ready for display.

Out of the workflow just described, the two areas that are of specific relevance to photo editing are Raw processing and post-production. For the purposes of this book we'll use the term Raw processing to describe all aspects of optimizing the Raw image file once it has been downloaded to the computer; post-production, on the other hand, we'll use to describe any aspect of optimization once the Raw file has been saved as a TIFF or JPEG. As you'll see later, this does have a bearing on the type of software you'll use for certain tasks.

The Raw Format

To understand Raw processing, you first need to be familiar with the Raw format. "Raw" is the generic term for the unprocessed file format available on all digital SLRs and many advanced compacts—whether Nikon's NEF, Sony's SR2, or Canon's CR2 format, to name just three. The benefits of shooting Raw are well documented, but are essentially concerned with capturing the most amount of image data possible. This data, rather than being processed automatically and indiscriminately by the camera as a JPEG, can instead be downloaded onto the computer, where you can manually process it using more powerful processors and software than are available in-camera. The end result, particularly with images shot under challenging lighting conditions, is improved tonal quality, sharper detail, and more accurate colors. Of course, you can process JPEGs instead, and much of the time JPEGs will provide perfectly good results. But when things get tough, you want as much data as possible in order to get the optimum result.

The dramatic improvement in Raw-processing software in recent years has allowed more optimization to take place at this initial stage than at the post-production end of the workflow. The benefits of optimizing at the Raw stage are: You have the greatest amount of leeway when correcting aspects such as exposure or color; and Raw processing is nondestructive—i.e., although on the surface you're altering how the image looks, the alterations are being relayed by a series of instructions (or "parameters") that simply overlay the original image data, which itself is left untouched and can be accessed again whenever you want. Post-production software, on the other hand, such as Photoshop or PaintShop Pro, alters the tonal and color values of the image's pixels themselves (hence the term "pixel editing," which you may have come across), and while up to a point you can track back and undo changes, saving the files is permanent.

Increasingly, therefore, it's good practice to perform as much optimization as possible in Raw processors. However, as we shall go on to discover, there are certain things that Raw-processing software can't achieve, and that's when you have to turn to post-production software.

Bearing in mind the distinction between these two optimization processes, the first sections of the book deal with Raw processing, the tools and techniques, while later sections cover post-production, paying particular attention to what can be achieved only with post-production software.

A Digital Photography Workflow

Capture

Import

Organize and Review

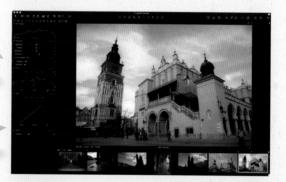

Raw processing

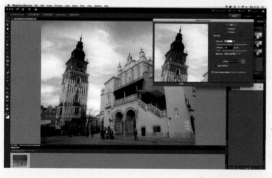

Post-production

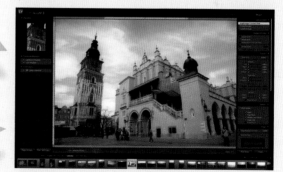

Distribution

Backup

Raw-Processing Software

Along with the development of more efficient image sensors and the ability to shoot video on DSLRs, another of the more significant advances in digital photography—certainly for those photographers who enjoy the editing process—is the development of Raw-processing software.

Early examples of Raw processors, such as the first releases of Adobe Camera Raw (ACR)—a plug-in that became available in 2002 with Photoshop 7.0.1—did not offer a great deal of freedom when it came to the adjustments that could be made to Raw files. Exposure, white balance, and color adjustments were well catered for; but

other features, such as sharpening, noise reduction, and fixing chromatic aberration were in their infancy, while yet more features such as lens correction, adjustment brushes, and spot removal didn't even exist.

As the true value of Raw processing became increasingly apparent in terms of the image quality it provided, software developers, such as Adobe, Apple, and Phase One to name just three, worked hard at developing Raw-processing software that was capable of an ever-broader range of adjustment. Camera manufacturers, such as Nikon and Canon, also developed their own Raw processors

that were designed specifically to work with their proprietary Raw formats. This was often bundled on CD-Rom with the purchase of the manufacturers' cameras.

Today's Raw-processing software has come a long way since these early examples. As the software has evolved it's become possible to undertake more and more image-editing tasks at the Raw-processing stage of the editing process. Processes such as sharpening, noise reduction, and fixing lens distortion and chromatic aberration are now performed by powerful algorithms that are capable of producing excellent results. These developments, together

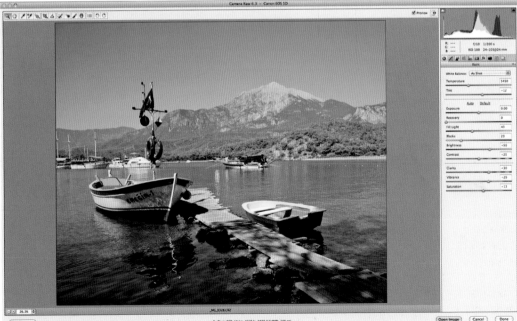

← Adobe Camera Raw (ACR)
This processor ships as a plug-in with Photoshop and Photoshop Elements, and is an extremely powerful Raw processing package in its own right. It features an almost identical image-editing toolset to Lightroom (in fact, it shares the same processing engine), only arranged and presented in a different way. As a plug-in, it works seamlessly with the rest of Photoshop or Elements.

with the advent of localized adjustment in the form of spot removal, editable adjustment brushes, and control points have almost rendered post-production software obsolete for certain types of photography. Many professionals today who shoot and edit large numbers of images, such as wedding or sports photographers, will often use only Raw-processing software to optimize their images. However, as we shall discover later, for other types of photography or for certain specific image-editing tasks, using post-production software such as Photoshop or PaintShop Pro is the only option.

Along with increasing the functionality of Raw processors, software developers have also taken the opportunity to develop programs that mirror the digital workflow. Taking the example of wedding or sports photographers again: Everything they need for their images, from importing and selecting, to optimizing and distributing, can all be achieved within the same program.

Adobe's Lightroom illustrates this perfectly. The program features five discrete modules or sections—Library, Develop, Slideshow, Print, and Web. Images are imported into the Library, where it's possible to select or create a new folder for the images, and add keywords and ratings. Optimization takes place in the Develop module. The Slideshow mode allows you to create presentations, incorporating watermarking and music to share as JPEG, PDF, or video slideshows. In the Print and Web sections you can prepare your images for both delivery methods. This structure is not unique to Lightroom; other Raw processors have similar modes, and are often referred to as "workflow software."

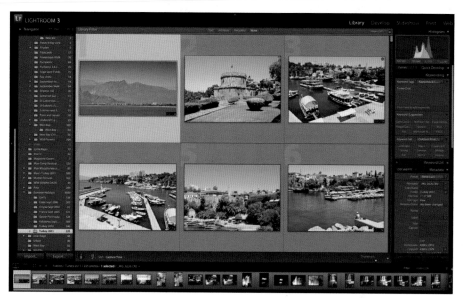

↑ Lightroom's Library module
This module behaves like a dedicated image database. Here you can view, compare, rank, organize, and add captions and keywords to your images. It's also possible to view the EXIF data embedded in the image.

↓ Apple's Aperture
Like Lightroom and Phase One's Capture One, Aperture is an extremely powerful Raw processor. It has a built-in image database, sophisticated editing capability, including localized adjustment tools, and a useful slideshow feature. It's even possible to send images to sites such as Facebook and Flickr at the touch of a button.

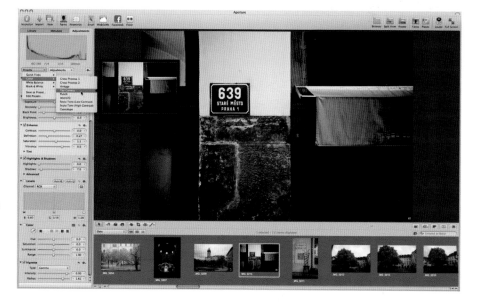

Post-Production Software

The history of post-production software is much longer than that of Raw processors, which are in fact relative newcomers in comparison.

It's no surprise that such software started with Adobe Photoshop. Photoshop, and the other programs that followed, were initially conceived of as general graphics packages. Photoshop's ability to create and manipulate vector graphics using features such as Paths and the Pen and Shape tools, together with the Text tool, reveals its identity as a graphics program. However, it also supports pixel-based, or raster, graphics, and as digital photography (with its pixel structure) has developed over the last decade or so, software companies have spent time developing tools for their pixel-based image editors that photographers find useful, such as Healing and Spot Removal brushes. However, unlike Raw processors that, with their workflow structure, are clearly aimed at photographers, Photoshop and most of the other pixel-based editors have a much broader audience. In fact, there are vast sections of Photoshop that are of limited use to photographers.

However, we can't be too dismissive of the program that most professional and many amateur photographers have embraced; and, of course, it's not just Photoshop. Photoshop Elements, PaintShop Pro, and the myriad other post-production programs are extremely powerful, versatile tools that many pros couldn't do without. The ability, should you so wish, to manually change each individual pixel in an image to whatever you want provides an unparalleled level of control. This powerful versatility, coupled with features such as layers, adjustment layers, masks, channels, and filters, ensures that, given enough time and with sufficient skills, you can make an image appear pretty much however you want. For professional photographers, notably in the fashion or advertising industries, the ability to edit at pixel level is essential. For such professional photographers, Raw-processing software—although perhaps initially useful for organizing and conducting a first edit—simply won't provide the comprehensive tools they need to create the final image.

In terms of workflow, unsurprisingly, complex programs such as Photoshop, which was developed before the concept of a digital photography workflow was a reality, cannot compete with the more recent Raw workflow software which has been developed with one eye always on workflow. Photoshop does, however, ship with a dedicated browser—Bridge—which is a perfectly adequate image organizer, and from which you can access Photoshop directly.

← Adobe Photoshop
Photoshop has evolved from a primarily graphics-intensive program into a comprehensive image-editing workhorse.

Less complex post-production software, such as Photoshop Elements and PaintShop Pro, have been redesigned over time to take into account the digital workflow approach. Elements, for example, has discrete workspace modules called Organize, Fix, Create, and Share, while PaintShop Pro takes a similar approach with its Manage, Adjust, and Edit workspaces.

Which Software Do You Need?

So the next obvious question is which type of software do you need? Well, that depends largely on what you shoot, the amount you shoot, and what your intended end use is. Most professionals will have both Raw processing and post-production software—and this is the ideal scenario; but for most amateurs this is probably not necessary. If you shoot a lot of images, but don't want to spend hours retouching them, and you're not too bothered about adding text or special effects, then Raw-processing software is likely to be most appropriate for your needs. These programs are generally quicker and more intuitive to use than pixel editors, and better at creating image libraries. And remember, although they're called Raw processors, you can edit JPEGs and TIFFs using the same nondestructive methods—the only difference is you won't have the benefit of the extra data you get from Raw files.

If, however, you enjoy manipulating images, such as merging elements from different photographs, and adding text or other special effects, then you'll need post-production software such as Photoshop, as Raw processors simply can't perform such tasks. And just as Raw processors will allow you to edit JPEGs or TIFFs, most pixel editors will allow you to process Raw files to a lesser or greater degree, before you convert to a TIFF or JPEG to complete the image editing.

↑ **Elements import window**
Photoshop Elements, while not quite as comprehensive as the full version of Photoshop, offers most of the features more commonly used by photographers, and also offers a complete workflow setup—beginning with this Import window.

↓ **Corel PaintShop Pro**
While Adobe certainly dominates the field of image-editing software, alternatives do exist. PaintShop Pro is a fully competent option, and one that has been around almost as long as Photoshop itself. Here, the workflow is divided among Manage, Adjust, and Edit modules.

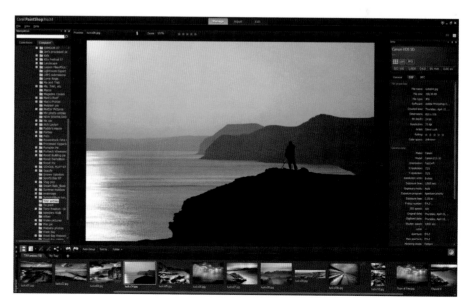

Raw-Processing Workspace

With workflow being just as important to Raw-processing software as image editing, it comes as no surprise to discover that most Raw processors have more than one workspace. Lightroom, for example, has five, while Apple's Aperture and Phase One's Capture One—two other popular Raw processors—have similar environments but with fewer modules. The broad approach of all these programs being: organize, edit, and share.

↓ Apple Aperture
Here, the program offers three discrete modules: Library, Metadata, and Adjustments.

The digital photography workflow begins with importing, and with most Raw processors simply attaching the camera or memory card to the computer and launching the software will prompt an import routine. At this stage you can create a folder in which to place the images, add keywords that are common to all the images, apply preset or customized picture settings, and embed metadata—which may include information about the photographer, any copyright notices, the date and location of the shoot, and so on. Getting into the habit of organizing your photos into folders and embedding keywords and other

metadata during the import routine will help you maintain a coherent image library later down the line. Once the images have downloaded to the Library you can quickly go through the collection ranking or deleting images, and making an initial selection of your favorites. With the selection made, you can add keywords that are specific to the individual images. If your intention is to sell your images via any of the numerous micro picture libraries that have cropped up on the Internet in recent years, keywords are essential as they help people search for your images.

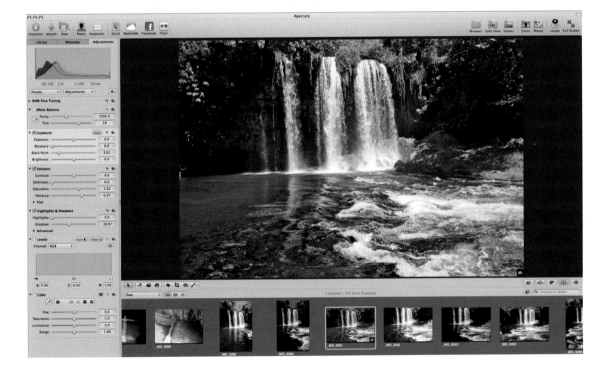

Develop

Lightroom's Develop module, like Aperture's Adjustments, is where all the image editing takes place. The Develop workspace is arranged into four main areas. Running down the left-hand side you'll find an extensive list of Lightroom preset photo styles, including a variety of black-and-white, cross-processed, and sepia-toned options, to name a small selection. These can be applied to an image simply by clicking on the preset name. Beneath these presets are Snapshots. This allows you to record the image-editing actions you've undertaken on one image and apply them to another. The History tab details the editing actions applied to the selected image. You can use History to retrace your steps and return to an earlier phase of the editing sequence.

The main image view located in the center of the screen shows a preview of the image. Naturally this updates as you apply different image-editing commands. You can toggle through the appearance of the preview using the icon found directly under the main view.

The right-hand panel is home to Lightroom's extensive range of image-editing tools. We'll look at these in greater detail later, but it's worth noting here that the tools are grouped together and organized into discrete palettes. Each palette relates to a specific area of editing, whether dealing with tone, color, or sharpening, for example. Like most of Lightroom's controls, the image-editing palettes can be expanded and collapsed by clicking on the small triangle next to its name.

↑ Before and after
By clicking on the icons underneath the image preview, you can call up a Before & After viewscreen, which gives you excellent perspective on the degree of adjustment you are making to the original image.

Beneath the main preview runs the filmstrip. This shows thumbnails of all the images in the selected folder. The filmstrip appears in all of the four modules and provides a way of accessing images without having to return to the Library each time. The Slideshow, Print, and Web modules all have a similar workspace, with control panels on either side of the main view, and the film strip running below. Although we've described in some detail the Lightroom workspace, as suggested earlier, other Raw processors share a similar structure.

Raw-Processing Tools

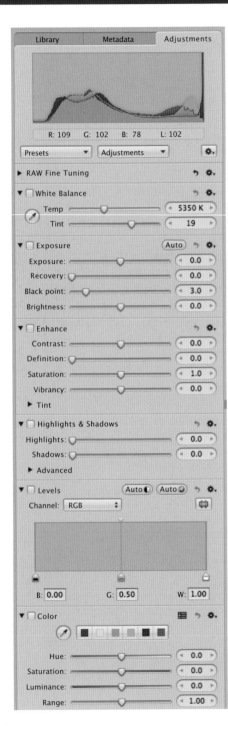

Although by no means identical, the similarity between the tool panels of much Raw-processing software is clear to see from the three examples shown here. Individual palettes or panels, each with readily identifiable names such as Exposure, Detail, Highlights & Shadows, and Lens Correction, feature a number of labeled sliders that can be accessed by clicking on the arrow that expands the palette. For the most part, it's clear what each of the sliders does—Brightness and Contrast, for example, are self-explanatory; and in less obvious cases, a slider's functionality is quickly learned by experimentation and observation. Because Raw processors, unlike many post-production pixel editors, have been designed from the ground up with photographers in mind, the palettes and their individual sliders are all closely associated with specific digital photography issues, and that's one of the things that helps to make Raw processors so intuitive.

With the majority of Raw processors, the sliders make adjustments in real time. In other words, as you move the Brightness slider, for example, the

←→ Aperture vs Lightroom
Aesthetic differences aside, it is easy to see the common tools that exist across various Raw processors—some of these tools even appear in the same order moving down the toolbar. Of course, the Lightroom toolbar shown right is cut off—it goes on for some length below; but each discrete palette can be collapsed when not in use, making it easier to scroll through all the various tools and sliders.

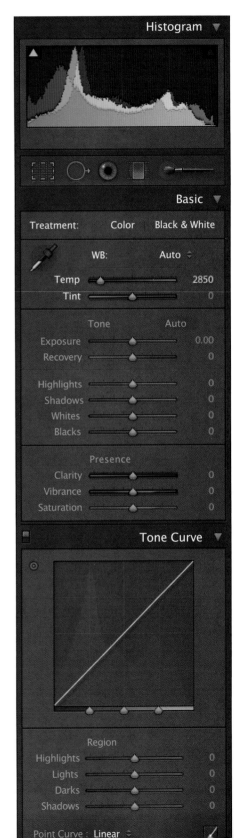

image will become lighter or darker corresponding to the movement of the slider—as opposed to the adjustment being made once you release the slider. This allows you to achieve the exact look you want instantly, rather than by trial and error. Although real-time image adjustment is not unique to Raw image-editors, it reinforces such software's user-friendliness. It is worth noting that the speed at which the software will display your adjustments depends on the capabilities of your particular hardware. If your computer is particularly stressed by running multiple applications, or if it doesn't have sufficient RAM, there may well be a delay between making your adjustments and the preview being updated to reflect them.

As well as making adjustments using the sliders, it's also usually possible to input specific numeric values in boxes next to the sliders. Although you're unlikely to make many adjustments this way initially, it can be useful if you're attempting to replicate specific settings between two different images.

As you progress through this book, you'll become increasingly familiar with what each control slider does, and the occasions when you'll use it. And over time you'll discover that there are some panels, palettes, and controls that you'll use frequently, while others that you'll barely utilize at all.

Keyboard Shortcuts

As I'm sure you are aware, nearly all computer programs have keyboard shortcuts that you can use instead of clicking on menus and commands with the cursor—and Raw processors are no exception.

As you become increasingly familiar with the program you're using, you'll find that you'll automatically begin to learn the more common shortcuts. It really pays to try to remember these—they increase the speed of your workflow considerably. For the time being, however, the most important shortcut to remember now is Ctrl/Cmd + Z. If you're not already familiar with this life-saver, it's "Undo" in most programs. So if you make a mistake, hit these keys to take a step back.

← Phase One's Capture One
While Phase One is primarily a high-end, medium-format camera manufacturer, they have also developed an impressive Raw processor called Capture One that is in most cases just as robust as other options from Adobe and Apple.

Post-Production Workspace

Photoshop is the undisputed king of the post-production pixel editors. It was the first image-editing software to have a truly global impact, and as such, most other editing programs have emulated it in regards to its tools, functions, menus, architecture, and commands. For this reason most of the terminology in the post-production sections of this book will have a bias toward Photoshop—although for the reasons stated on the previous pages, it should be clear to users of other programs which tools or menus are being referred to. It's probably also fair to say that if you've mastered Photoshop, it won't take you long to master other pixel-editing programs.

Despite being the heavyweight of image-editors, Photoshop is certainly not a big-hitter when it comes to efficient workflow (of course, it was never intended to be). Before the arrival of the Bridge plug-in, Photoshop had no form of browser or image organizer at all. And even now, in comparison with Raw-processing software, jumping between Bridge and Photoshop is still slow and rather cumbersome.

In terms of workflow, the less powerful, but often perfectly satisfactory pixel editors such as Photoshop Elements or PaintShop Pro are more useful, certainly for the amateur photographer. These emulate the workspaces of Raw processors, such as Lightroom and Aperture, by having discrete modules in which you can organize, edit, and share your images. Although switching between the various modules is not as seamless as it can be with Raw processors, you do at least have all the tools you need to create, edit, and share images from an image library.

Turning to the main image-editing workspace of post-production software, what is immediately obvious is that there's a great deal to take on. While with many Raw processors you can find your way around on your own in a relatively short space of time, with pixel editors and certainly with Photoshop, delving into the program without prior instruction is likely to result in mental meltdown. It's exactly for this reason that "consumer" versions such as Photoshop Elements have readily accessible tutorials that help you learn your way. Photoshop has none of these, so you really need to spend some time learning the basics before you can begin to reap the rewards of the powerful software. Photoshop's main workspace is relatively clutter free. However, this belies the sophisticated toolset that accompanies the software. Shown opposite are images of Photoshop's and PaintShop Pro's Edit workspace, showing how similar they are.

← Adobe Bridge
You can customize this main screen to offer a wide variety of additional information, or clear it of everything but your image thumbnails to get a light-table workspace.

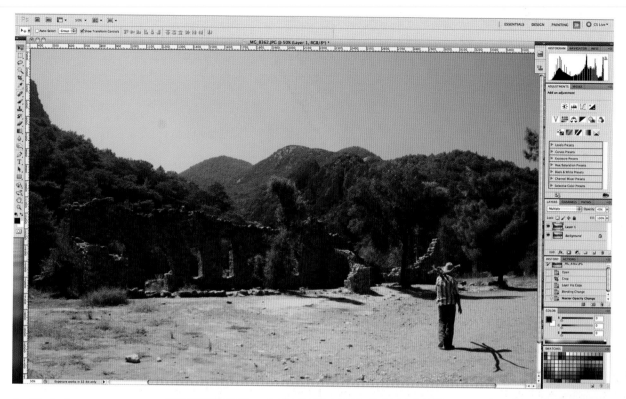

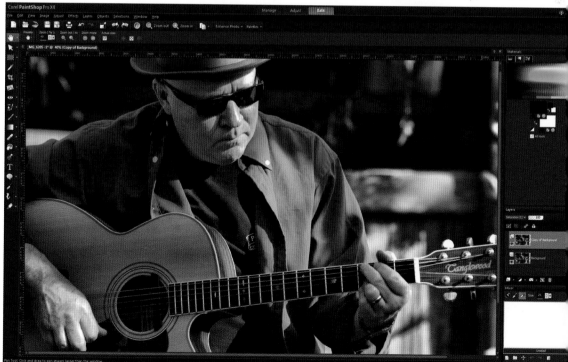

↑→ Photoshop vs PaintShop Pro

There are quite a few commonalities to be seen between these two image-editing programs. The main toolbars are both arranged along the left side, with tool options stretching horizontally from the upper left. The right side is dominated by a series of palettes, with Layers being the most significant feature.

Post-Production Tools

Compared with Raw processors, post-production pixel editors are rather less intuitive and have a more complex toolset to learn.

Much of the complexity of post-production pixel editors is due to the fact that, unlike most Raw processors in which the tools are primarily grouped together in one long panel, pixel editors have a whole host of tools, dialogs, commands, and menus dotted around the workspace. It's true that many of the mid-level editors such as Photoshop Elements and PaintShop Pro now feature user-friendly wizards and tutorials that help you perform specific tasks, but you'll find that when you come to perform an editing task, rather than reaching for a single slider, as you more often than not are able to do with Raw processors, with pixel editors you may find you have to open and use a number of various tools, commands, and dialogs to achieve a similar result.

However, once you've learned your way around one piece of post-production software, you'll begin to appreciate how powerful these pixel editors are—as mentioned earlier, there are things you can do with pixel post-production software that are simply not possible with Raw-processing software.

↑ Tool options
As well as the main Toolbox, to which you'll turn in order to select specific tools, pixel editors also tend to feature Tool Options bars. Here you can adapt the functionality of the tool, or its size and shape, for example, to make it more suitable for the task in hand.

← Learning tool names and hot keys
With most post-production programs, hovering the cursor for a second or two over a specific tool will usually cause the name of the tool to appear. This is certainly beneficial when you're learning a new application. Note that the keyboard shortcut often appears next to the name.

Type Tool (T)

← Photoshop toolbar
Many of the tool icons utilized by post-production pixel editors are now almost generic. The Crop tool, Eyedropper, Type tool, and many others are the same across a number of applications. This certainly makes it easier when switching between programs.

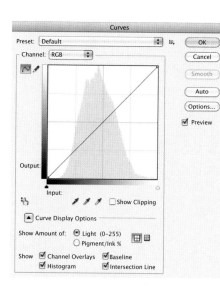

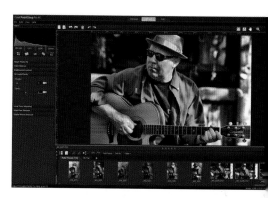

↑↓ Look for the similarities

Although the many adjustment panels, dialogs, and palettes make learning image-editing software such as PaintShop Pro and, in particular Photoshop, a lengthy process, it is precisely these controls that make such software so powerful and adaptable. Layers and Curves, for example, as you'll discover later, are key to many of the editing tasks you'll be undertaking using pixel editors. Fortunately, as with the tools themselves, there are many cross-overs when it comes to the fundamental way in which pixel editors work. Layers and Curves are just two commands that you'll find in most mid-level and professional pixel-editing software.

←↑ Sidebars and palettes

What many users new to post-production software find confusing is that, in addition to the numerous tools and tool options (which in themselves take time to learn), there is also a seemingly endless collection of palettes and other adjustment controls that have to be mastered.

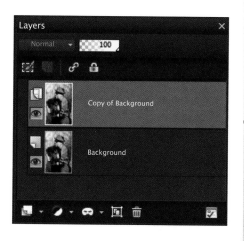

Basic Image Optimization

One of the distinct advantages of shooting in the Raw format is the level of adjustment you can make to the image file at the Raw conversion stage—and all without any visible loss in quality. Inaccurate white balance setting? Not a problem, as you can apply any preset you like in Raw-processing software, or manually set a precise color temperature to ensure your whites are white. Exposure too bright or too dark? Again, not an issue. You can radically adjust the exposure without degrading image quality; and what's more, you can target and fix over- and underexposed areas independently of one another just by moving a couple of sliders.

In this chapter you'll learn how to make such adjustments with confidence. Also covered are other basic editing tasks such as cropping and rotating, and how to remove spots and blemishes. The section finishes with essential information on sharpening and controlling noise. Raw files by their very nature are inherently "soft" directly out of the camera, and so "presharpening" or "capture sharpening" is an essential part of the Raw-processing workflow. However, sharpening an image can sometimes result in the introduction of noise. For this reason, with many Raw editors you'll discover that the sliders used to combat noise sit close to those that govern sharpening. All these controls are examined in detail so that you'll learn how to extract the most detail out of your images without introducing unwanted artifacts.

Rotating & Cropping

One of the first assessments you're likely to make of an image before progressing with other editing tasks is deciding whether or not the image is straight. Depending on the particular shot, this may not be too critical, but if there are distinctive horizontals or a horizon visible in the shot, you'll want to ensure that the frame is properly aligned with these linear elements contained within it.

Cropping an image—essentially, removing any unwanted part of a composition—is another simple editing task, and yet potentially one of the most effective ways of ensuring a photo has the greatest possible impact.

Naturally, we should always be thinking of composition when we're framing our photos, but often we're shooting at speed or grabbing a shot under rapidly changing lighting conditions, and it's not until later, when we have time to fully assess an image on a computer monitor, that we can see how the composition of the image can be improved. It may also be the case that there are some alternative crops we'd like to try to see which works best.

Another reason for cropping is that the image size and shape is dictated by something outside of our control. Perhaps the final image requirement is for a square shot, in which case you'll need to crop a landscape or portrait format to suit.

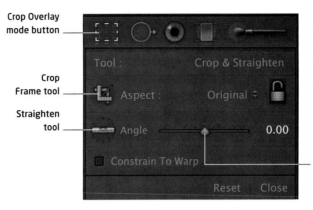

Crop Overlay mode button

Crop Frame tool

Straighten tool

Lightroom's crop palette
This palette is found near the top of the Develop module under the histogram. To reveal the various tools associated with the Crop Overlay mode, click the dotted rectangle (or press R).

Straighten Slider control

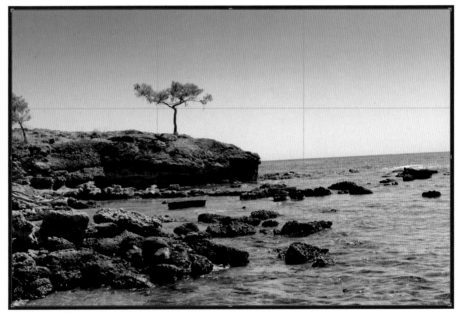

Grid overlay
Having selected the Crop mode, a grid will be displayed over the image. At the corners of the image and in the center of each side are bounding box handles.

Grid options
Above we've selected the Thirds grid, but other options include Golden Ratio, Triangle, or Golden Spiral, all of which are intended to help with composition (though they are all doubtful formulas to apply without careful thought.)

✓ Grid
Thirds
Diagonal
Triangle
Golden Ratio
Golden Spiral

Cycle Grid Overlay O
Cycle Grid Overlay Orientation ⇧O

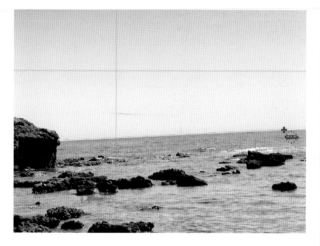

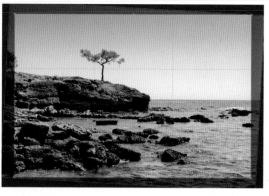

↑ **Rotate options**

There are a number of ways to rotate an image. If you place the cursor near a corner box handle it will turn into a double-headed arrow. Move the cursor up or down and the image will rotate. However, a more accurate method is to select the Straighten tool. On the image draw a line along the horizon or horizontal line that you're using as a point of reference. As soon as you've drawn the line and released the mouse button, the image will automatically rotate. Notice also, that the image is automatically cropped to accommodate the rotation.

↑ ← **Cut out distractions**

To tidy up the image and improve the crop, using the Thirds grid the left-hand control point was dragged to the right so that the slightly distracting tree at the edge of the frame is cropped out, and so that the remaining solitary tree sits on a rule of thirds line. The top handle was then dragged down so that the ocean horizon is in the middle of the frame, giving the final image a better sense of balance.

© Steve Luck

Correcting White Balance

We're all aware that daylight can actually change color during the course of the day, from an orange hue just after sunrise, through the purer, almost blue white light of midday, and then warming up again as the sun sets. But the color temperature of light is also affected by atmospheric conditions such as clouds, or more dramatically by artificial light sources such as streetlamps or even lightbulbs.

To ensure that white objects always appear white, no matter what the ambient color temperature, your camera has a variety of white balance settings—these usually have names such as Daylight, Cloud, Shady, Tungsten, Incandescent, Flash, and so on. And, in fact, most cameras will perform adequately if left on the Auto setting. However, every now and again you may come across a shooting situation that has the camera fooled —a mixture of natural and artificial light, for example, which results in an image that exhibits some odd-looking color casts.

Shooting Raw is the best way to ensure that you can freely adjust the color balance when editing your images. If you shoot Raw, no matter what the camera's white balance setting at the time of shooting, you can alter this to give a more (or less, if you want a creative interpretation) neutral result without impacting on image quality in any way.

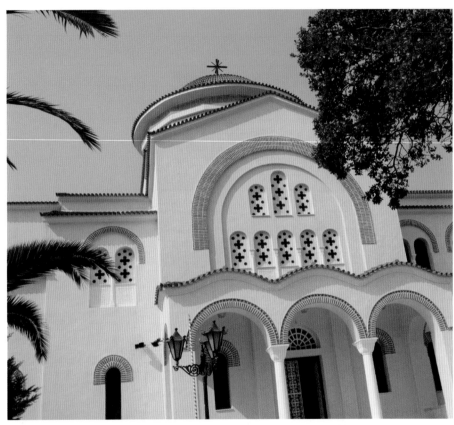

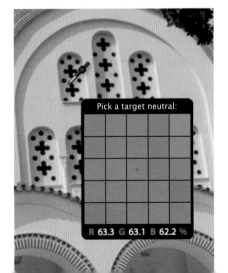

Pick a target neutral:

R 63.3 G 63.1 B 62.2 %

↑ Not quite blue enough
Although the lighting (daylight) in this shot of a Greek monastery was neutral, the Auto setting has produced a slightly orange image. The sky isn't as blue as it should be and the overall effect is a muddy appearance.

← A neutral target
With the Raw processor's Eyedropper tool selected, click on a neutral gray pixel—try to get the red, green, and blue values as close as possible.

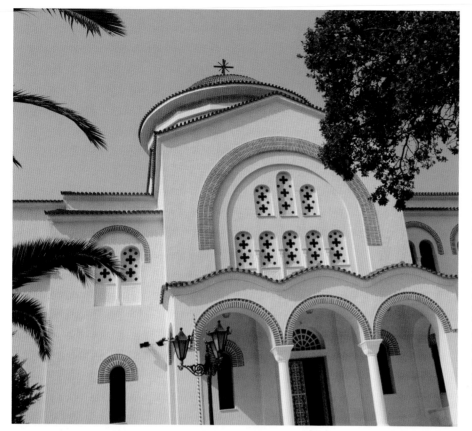

Blue sky restored

As soon as you select a neutral-gray area, the software automatically balances the colors in the image, and the result is a photo free from the orange color cast.

Avoid clicking on an area that's too white or bright, as one of the color channels may be clipped (exhibiting only the maximum intensity of the color with no detail), resulting in an inaccurate white balance measurement, which in turn could produce an inaccurate color adjustment.

If for some reason using the Eyedropper doesn't produce a result you're happy with, use the Raw processor's Temperature and Tint sliders to manually adjust the white balance. Raw processors even have some presets that might provide you with the result you want.

Creative white balance

You can use the Raw processor's white balance sliders in a creative rather than purely prescriptive way. White balance can be subjective, with no actual right or wrong result, so use the sliders to cool down or warm up the image for very different results.

Adjusting Exposure

Of all the benefits of shooting and editing in the Raw format, perhaps the greatest is the level of adjustment that can be made to the image's exposure long after you've pressed the shutter release. In most cases it's possible to increase or decrease the exposure setting by around two stops in Raw-processing software—making a total possible adjustment of up to four stops—without affecting the quality of the image. Furthermore, the adjustment doesn't necessarily have to be made to the image as a whole. It's possible to make only certain areas brighter while holding (or even reducing) the exposure in other areas—although care needs to be taken to ensure that such an adjustment doesn't result in an unrealistic image.

Adjusting exposure is a key aspect of image optimization—the process of making an image look its best—and involves ensuring that the image has the fullest possible range of tones. The golden rule of optimization is to avoid overly clipped highlights. When highlights are clipped too much you lose important detail; however, if they are not bright enough the image can appear dull and flat.

As well as setting the highlights or white point, you'll also need to set the black point. This determines how much detail remains visible in shadow regions. This is less crucial than setting the white point, as our eyes are less drawn to pure black in an image than they are pure white; and much of the time setting the black point is a matter of personal taste.

© Steve Luck

↑ **Mostly underexposed**
Shot outside in dappled, contrasty lighting, a spot-meter reading from the guitarist's face has ensured the most important element of the image is not overexposed, but has left the rest of the image too dark.

↑ **Global exposure increase**
Using the Raw processor's exposure controls, we can globally increase the exposure by a couple of stops. This has improved the overall exposure, but the face now looks overexposed.

↑ **Highlight clipping warning**
Activating this feature indeed shows that parts of the musician's face are in fact blowing out—they've become pure white and have lost detail altogether. It's essential that we fix this if the image is to be successful.

↑ Recovery/Highlights slider

This slider tool, an essential part of most Raw processors, will darken highlights and (with any luck) add back some lost detail. Holding down the Alt or Cmd key, depending on the Raw processor you're using, while moving the slider will reveal the elements of the image that are clipping against a black background. Here, the

blown highlights on the face have been recovered, and the only ones now clipping are the specular highlights of the guitar's white edge. These are acceptable. Returning to the main preview, we can see that the face is no longer overexposed.

↑ Setting the black point

Using the Black or black-point slider, and again holding down the Alt or Cmd key, move the slider until the shadows are just beginning to clip. This will give the image a richer appearance with better contrast.

© Steve Luck

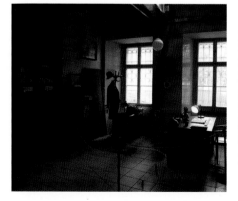

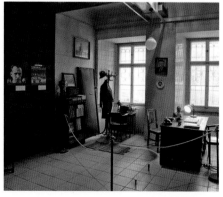

← Shadow fill

The ability to open up shadows in an image without affecting the highlights is another relatively new aspect of Raw editing. Lightroom's and Aperture's Shadows slider (sometimes called the Fill Light slider in other programs) both perform the task exceptionally well. Here, we've used a Raw processor to lighten the interior of a room in the Communist museum in Prague without losing detail around and outside the windows.

Challenge

Basic Image Optimization

↓ Low-contrast original
Intentionally shooting with low contrast and low saturation levels is often a wise choice—it lets you concentrate on the essential qualities of exposure and composition without getting distracted by trying to make the image "pop" straight out of the camera. Such inclinations are best left to dedicated post-production software.

Now that you are shooting Raw, it's time to get in the habit of making those initial, essential adjustments to your images as soon as you open them up in your Raw processor. Is the image lined up with the horizon? Is the white balance accurate? And even if it is, do you want to portray this subject accurately or creatively? As this is all nondestructive editing at this point,

feel free to experiment. Sometimes it would never occur to you to warm up an image's tones until you slide the Temp scale a bit to the right (just for an example). And finally, take a look at your exposure—maybe with the highlight/shadow warning activated, and see if there's any detail you want to recover hidden away at the far sides of the histogram.

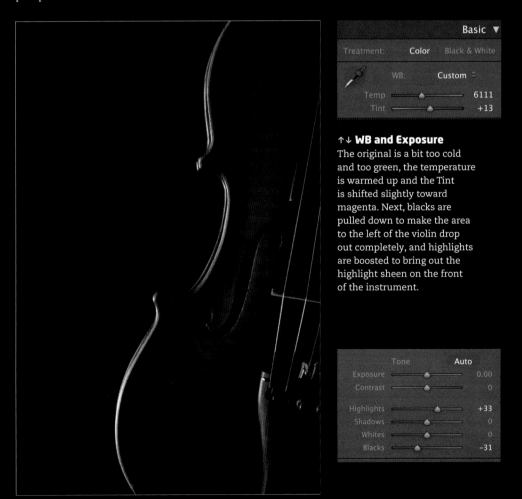

↑↓ WB and Exposure
The original is a bit too cold and too green, the temperature is warmed up and the Tint is shifted slightly toward magenta. Next, blacks are pulled down to make the area to the left of the violin drop out completely, and highlights are boosted to bring out the highlight sheen on the front of the instrument.

→ Optimized and ready

Sometimes all it takes to find a backlit shot is changing your angle—in this case, looking straight up. Careful positioning and composition is key.

Challenge Checklist

→ Even if you set an exact custom white balance, check that there isn't some other possible, more flattering color cast by experimenting with your Temp and Tint sliders.

→ Your highlight and shadow clipping warnings can be invaluable—often its difficult to discern the exact levels of exposure with the naked eye.

→ When you're finished, save the image as a Tiff, but always archive the original Raw file for future reference.

Review

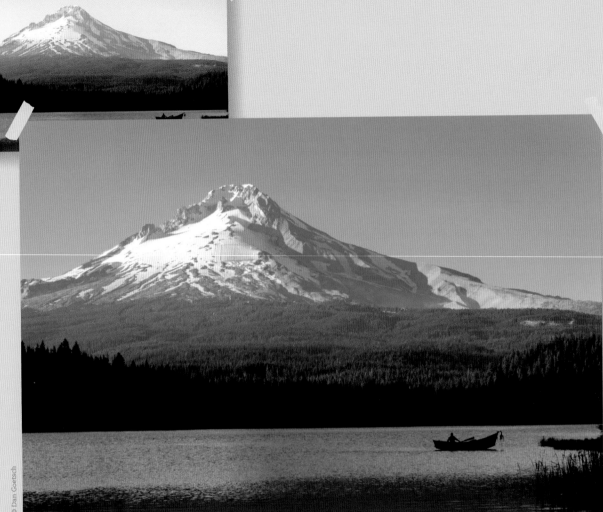

© Dan Goetsch

While Trillium Lake was beautiful, the sunset on Mount Hood was a bit of a let down. The position of the sun was washing out some of the deep blues. In Photoshop, I brought the blues back in with the color balance, and set it up with different layer masks to affect only the sky. I did the same to bring back some of the yellows and greens for the tree line, then merged the layers and adjusted vibrance to make it look natural and closer to what I was seeing in person versus what the camera saw.

Dan Goetsch

Well-executed recovery, particularly of the blue sky, which can end up looking false and/or banded if carelessly done. More than that, this is a good example of the need to rely on your own perception of what the image should look like, because you were there and knew what you wanted.

Michael Freeman

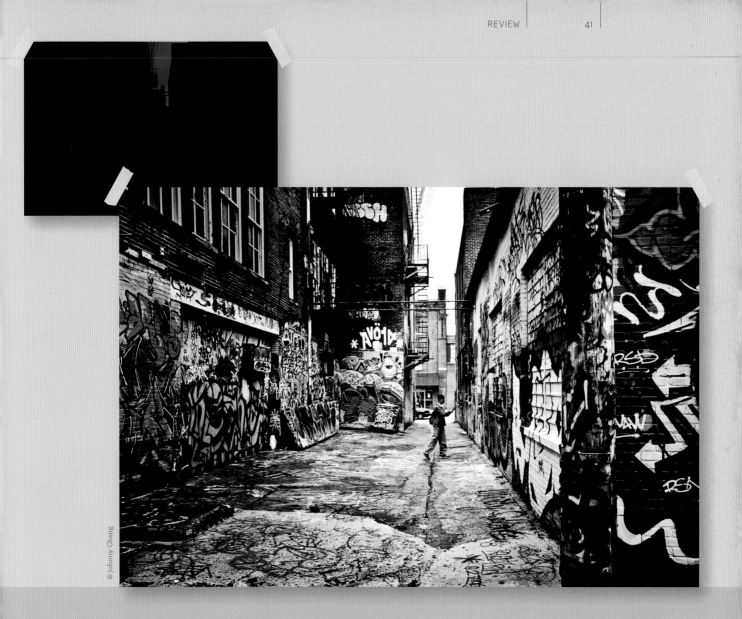

© Johnny Chang

To combat the underexposure, I added almost 4 stops to the entire photo. Then, I wanted to make the graffiti artist blend into his work by making him and his surroundings appear more graphic novel-esque, so I converted to black and white and worked on increasing the contrast. Then I manually added vignetting with the adjustment brush to focus in on him. I then dodged and burned various parts of the image to my taste. I also played with grayscale mix to get the right blend of each color.
Johnny Chang

A lot of work went into this, and successfully given your aim. I like the idea behind it, and that you included the ground in the treatment. I'd be interested to know why you underexposed so strongly, according to the attached original.
Michael Freeman

Removing Spots & Blemishes

Many of the spots you see on digital photographs are caused by dust on the image sensor. This primarily affects DSLRs, and occurs when dust enters the camera body—when a lens is being changed for example—and settles on the sensor's surface. Fortunately, such spots are only really noticeable in areas of flat color, such as blue skies. Getting rid of most spots is quick and easy, although with others, you may have to work a bit harder to remove them.

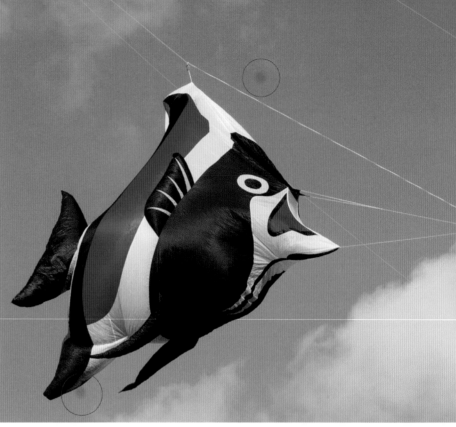
© Steve Luck

↑ Select the dust spot
Select the Spot Removal tool or Retouch brush Check that the tool is in Heal mode. Adjust the size of the tool or brush so that it fits neatly over the dust spot. There are usually keys you can use to adjust the brush size—it's quicker and more accurate than using the slider.

↑ Sample a separate area
With the tool fitting neatly over the dust spot simply click the mouse. The Raw processor will automatically choose a sample area (usually adjacent to the target area) that it uses to blend with the pixels from the target area, so removing the spot.

↑ A clear sky regained
In a matter of moments, the ugly dust spot has disappeared, and we're ready to move on to the next problem area.

↑ ↗ Trickier edges

Here, the dust spot is located close to a dark edge of the kite. Let's see what happens if we use Spot Removal or Retouch brush in Heal mode, and simply click the mouse button.

As before, the Raw processor automatically selects a sample area to blend with the target area.

However, here the result is unsatisfactory. First, because the sample circle hasn't aligned with the target circle. Second, because in Heal mode the Removal tool uses pixels from the edge of the target circle when blending with the sample.

↑ ↗ A case for cloning

Where the spot is near an edge, change to Clone mode, in which the Spot Removal tool doesn't attempt to blend the surrounding pixels. This provides a more clearly defined blending edge. Here, we've selected the sample and dragged it away from the kite to a cleaner position.

Moving the sample area to a more appropriate position has resulted in a better alignment, while the Clone mode creates a cleaner result.

↑ Applied to a portrait

The Spot Removal tool or Retouch brush, when in Heal mode, is an ideal way to remove skin and other blemishes.

© Steve Luck

Challenge

Remove Dust Spots or Blemishes

↓ Ideal dust conditions

A windy, sandy beach, shot at a narrow aperture (to include a sharp foreground) and with the bright sky taking up just over half of the frame, is the exact type of shot that will make dust noticeable. Fortunately, that also means it will be easy to find and remove in post-production.

It's time to zoom in to full 1:1 magnification and inspect your image file for any annoying little details that are out of place. Dust isn't always a problem—even if it's there on your sensor, it may not be visible under every condition. However, if you used a narrow aperture and included vast swaths of sky in your frame, these are the ideal conditions for making such

imperfections readily visible. While this stage of your editing workflow might seem painstaking, remember that with the spot removal and healing brush, blemishes and dust spots are gone with a click of the mouse.

←↙ Easy spot removal

Dust spots can often appear grouped together, and indeed there are two patches here, each consisting of three little splotches that are gone with a simple click of the Spot Removal brush set to Heal mode. Beyond that, there are also a few pieces of debris along the beach at the bottom of the frame that make the composition a bit untidy. For them, the Spot Removal brush is set to Clone mode and directed to copy from a few other areas of the beach, to make the cleanup appear natural.

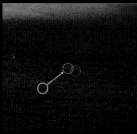

Challenge Checklist

→ Pull your editing window to the full size of your computer screen, and set the image magnification to 1:1.

→ When cloning, sample from a few different areas of the frame, to randomize your selection and make the results appear more natural.

→ If you're touching up a portrait, don't get carried away—concentrate on removing the distracting blemishes only. You're not a plastic surgeon!

↓ **Clear skies, clean beach**
The sky is dust-free, and the beach below is now clear enough to permit the image's use as a graphic with text overlay at the bottom. Those pieces of debris in the sand may not have been that big of a problem, but cleaning them up gave this image more potential for other uses.

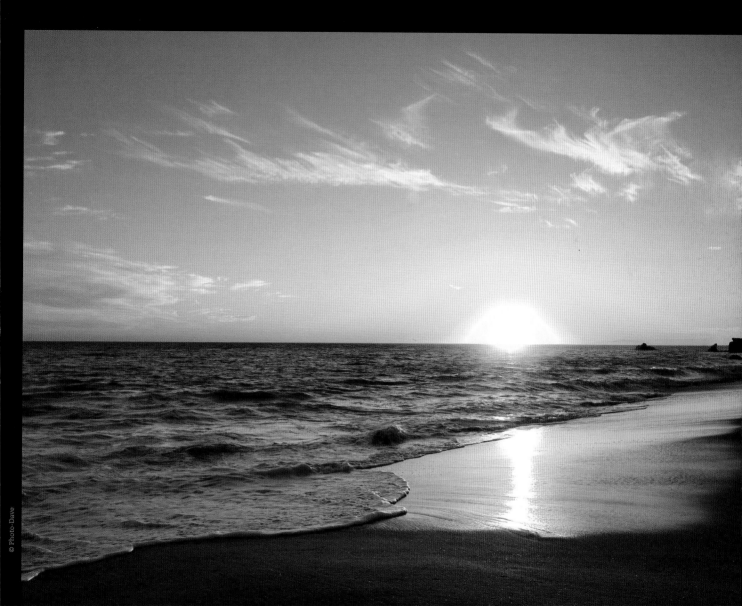

Review

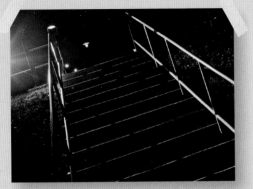

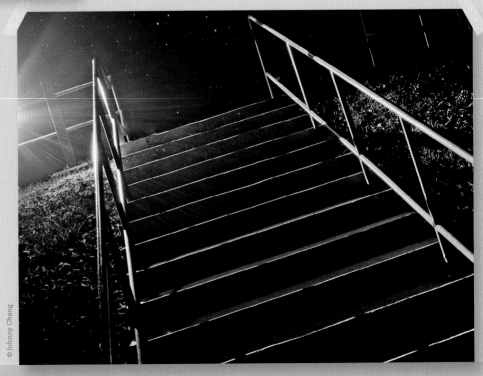

© Johnny Chang

Tilted to desired composition and converted to black and white. I cloned out the lamps in the background and some of the "stars" in front of the stairs, which were actually all rain drops lit by my strobe, camera left. Then I selectively burned highlights (particularly the rails) and dodged areas of the grass to bring in detail. I added a bit of a cold tint to add a sort of eerie feeling.

Johnny Chang

Looks like enough raindrops were left to add a misty quality to this night shot, but you can see that removing the most distracting spots—the ones with the most glare at the top of the stairs—definitely helps the final shot. It's always a personal call deciding what to take out.

Michael Freeman

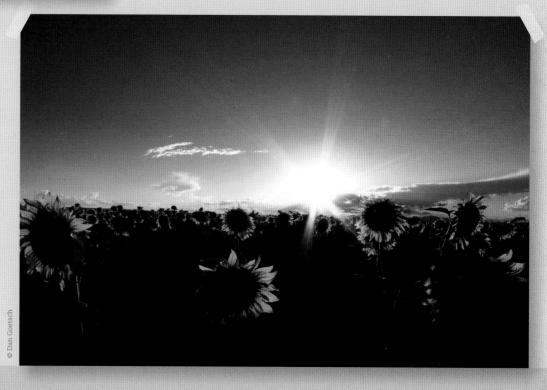

© Dan Goetsch

Shooting into the sun at this time of day provides two different outputs unless you have a nice graduated ND filter. You either get the details in the highlights and lose what's in the shadows, or vice versa. In Camera Raw I used the Graduated filter and increased the brightness on the bottom half while darkening the top half. After doing that I noticed all the camera sensor dust, which I took out with the Spot Removal in ACR. Once that was done I sharpened the photo and bumped the vibrance a little.
Dan Goetsch

Dust or no, with changing lighting conditions like this setting sun, sometimes you have to act fast and think later. Looks like the dust spots (not to be confused with the flare artifacts, which add a nice element to the composition) were easy enough to remove as they were obvious against a dark blue sky.
Michael Freeman

Sharpening

We've learned a lot about sharpening digital images over the last few years—and software manufacturers have too. Sharpening procedures and tools have become increasingly sophisticated, and this has continued as Raw processors have also developed and improved.

Recently, distinctions have been made between capture sharpening and output sharpening. Capture sharpening is the sharpening applied to a Raw image file during Raw processing. The idea behind capture sharpening is that it counteracts the softening effect of the low-pass or anti-aliasing filter that sits directly in front of the camera sensor. When shooting Raw, no in-camera sharpening is applied as it is with JPEGs, therefore you need to sharpen an image so that it looks crisp on-screen; and that is what we're going to cover here—how far to apply it, and what to avoid.

Output sharpening, on the other hand, takes place at the end of all other post-production tasks, and is essentially concerned with preparing an image for print or screen display. Output sharpening is mostly automated through the Raw processor's preset controls when you go to print or save an image for the web, and is not particularly in the remit of this book.

↗→ **Straight from the camera**
This image of an old tractor has been reproduced straight from the Raw file, and although optimized for color and tone, no capture sharpening has been applied. You can see from the close-up view that the image is soft, and the abundant texture of the metal is not rendered as sharply as it could be.

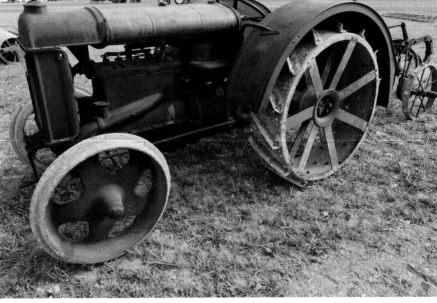

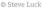
© Steve Luck

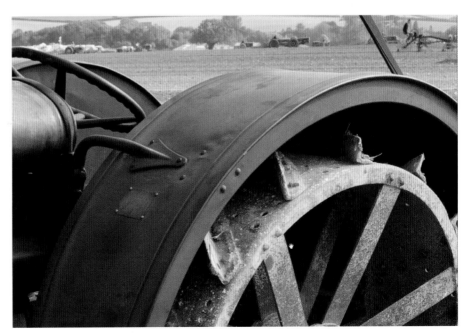

The aim of capture sharpening is to get the image to look pleasingly sharp on-screen. Don't sharpen the image so much that it begins to exhibit ugly halos or visible noise.

Most Raw processors have one main sharpening slider that applies an overall sharpening effect. In the side-by-side comparison shown right, Lightroom's Amount slider has been increased from the default 25 to 70 (on the left) and the maximum 150 (on the right). It's clear that the maximum setting has oversharpened the image, as there are visible artifacts. At a setting of 70 the image is visibly sharper, and although the artifacts are less obvious, there is still some noise visible in the flatter areas of the image.

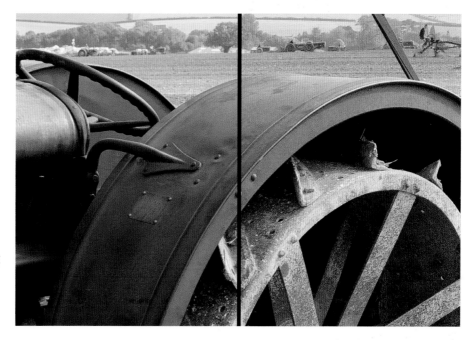

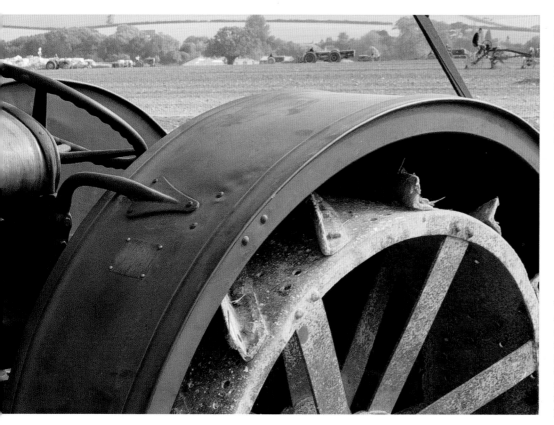

↑ View at 1:1
Before you begin to sharpen any image, it's essential that you view the image at 100%, 1:1, or actual size (different terms for the same thing). Viewing the image at a smaller scale won't provide you with an accurate preview of the sharpening effects.

← Grayscale preview
With Lightroom, holding the Alt/Opt key while adjusting any of the sharpening controls renders the preview as a grayscale image. This essentially makes it easier to see which part of the image is being affected by the particular adjustment.

Sharpening

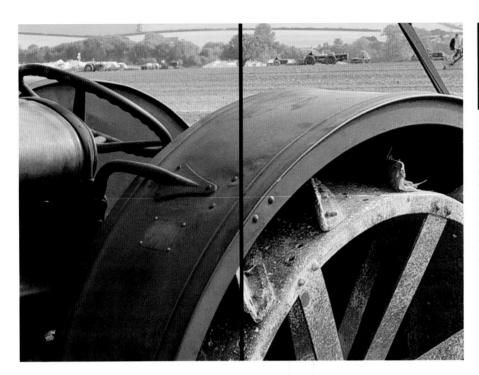

←↑ Sharpening controls

Lightroom's Radius slider controls how sharpening is applied to details. With a low setting (as on the left) sharpening is applied only to fine details. Increasing the Radius setting applies sharpening to larger details (as on the right). Generally, a high Radius setting will often result in ugly artifacts. As a rule of thumb, if you're sharpening an image with a lot of fine detail, a Radius setting between 0.5 and 1 is usually sufficient.

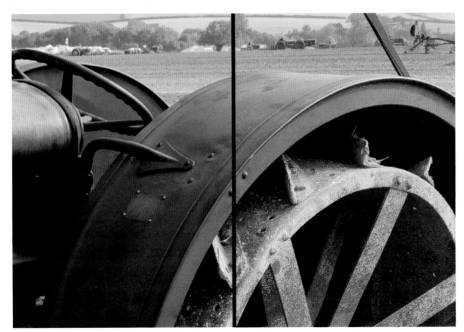

← Combatting halos

Lightroom's Detail slider helps to reduce halos—unnaturally light or white edges, usually along a high-contrast area. A low Detail setting (on the left) ensures that sharpening is applied only on the very edges, while a high Detail setting (right) results in sharpening being applied to much more of the image. Here we want the Detail setting to bring out the texture of the rougher metal but to hold back sharpening artifacts on the smoother metal. Like most adjustments, a trial-and-error approach is the best method—simply move the slider until you strike the most appealing balance between detail and artifacts.

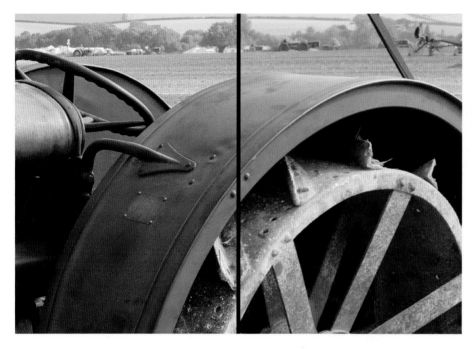

↑← Mask out smooth areas

Lightroom's Masking slider, like the Detail control, is a way of suppressing the two active sharpening commands. A low Masking setting (left) applies almost no mask at all, resulting in almost no change to the sharpening effect. A high setting applies a mask on everything but high-contrast edges. This is a good way of ensuring that sharpening is applied to edges but not to flat tonal areas, where noise is often more apparent.

→ Sharpening complete

The final image following capture sharpening is much crisper and shows more textural detail without the introduction of halos, noise, or other sharpening artifacts. This image is now ready for further post-production work, if necessary.

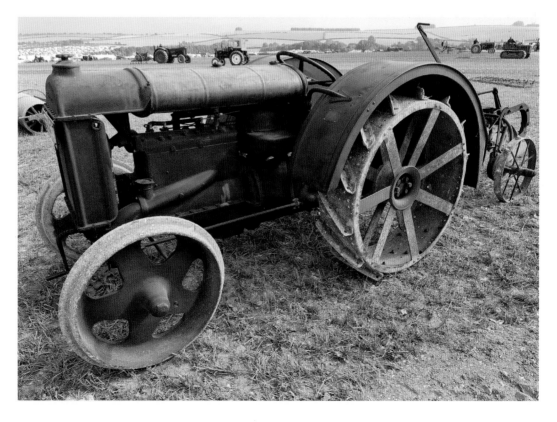

Sharpen Up a Shot

Challenge

↓ **Cathedral interior**
This straight-from-the-camera Raw file is clearly soft, both because sharpening was set to 0 and because a high ISO was used, and the resulting noise needs to be smoothed over a bit—further softening the shot.

You've already been challenged to shoot into the sun, which will normally impose a backlit scenario. Now you're challenged to capture a backlit shot using some other light source. You can set up this shot in your home studio if you like, and position your lights behind your subject. However, keep an eye out for backlit shots in the everyday as well; you'll be surprised how readily available they are. The substance of your subject will also come into play here—is it solid enough to completely block the back-light? Or is it perhaps transparent/translucent, giving you an opportunity to look through the subject itself?

←↙ **Soft to sharp**
While it may look acceptable at a distance, zooming in to full 1:1 magnification makes it clear that the delicate ridges of the architecture are not being rendered nearly as crisply as they should be. As these are very fine details, a relatively small radius is set; and as most of the frame contains intricate architectural textures, the Detail slider is left at a safe 25. The Amount slider is simply increased little by little until the magnified view looks crisp on-screen.

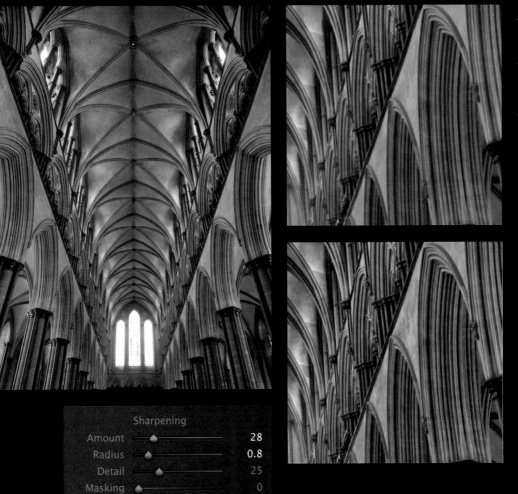

Sharpening		
Amount		28
Radius		0.8
Detail		25
Masking		0

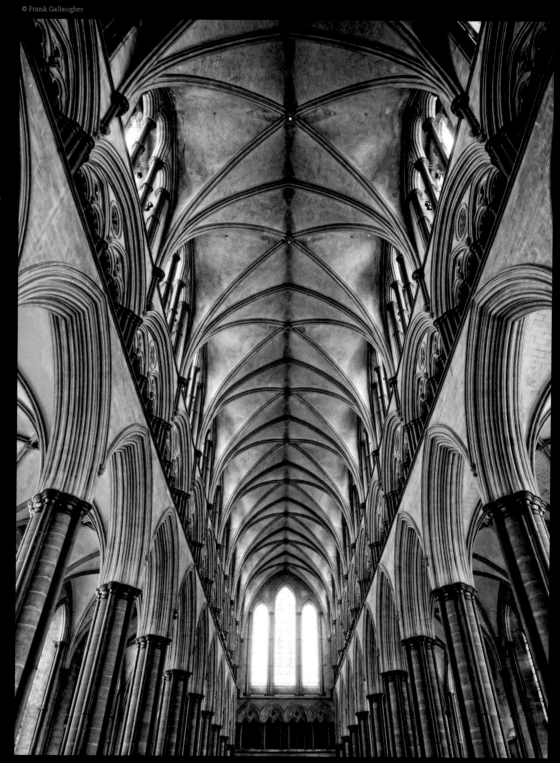

© Frank Gallaugher

→ **Ready for processing**

After the capture sharpening is applied, the rest of the editing workflow consisted of a simple tweak to the colors and saturation levels. But it's the sharpening that really brought this shot to life, and the abundance of fine detail it now exhibits draws the viewer in without introducing any ugly artifacts or grain.

Challenge Checklist

→ It's best to use a light touch at first, and always keep an eye out for distracting sharpening artifacts that may start to appear in empty areas of the frame—a clear sign you've oversharpened.

→ If your image has a mixture of empty areas that don't need much sharpening, and intricate details that would benefit from a relatively strong sharpening, make use of your Detail and Masking slider to strike a pleasing balance across the frame.

Review

© Faith Kashefska-Lefever

After assembling each photo in Photoshop, I merged the layers together so they were all on the same layer. I went into the Filter menu, down to Sharpen and selected the Unsharp Mask. Setting the radius to 2.9 pixels at 105% gave me a crisp and clear image that would be ready for large printing.

Faith Kashefska-Lefever

Sharpening for printing is different from sharpening to compensate for loss of crispness in capture, hence the high radius here, I assume. It's all about appearance, and that looks the right amount for this example. I'm also assuming that you archived the original file without sharpening!

Michael Freeman

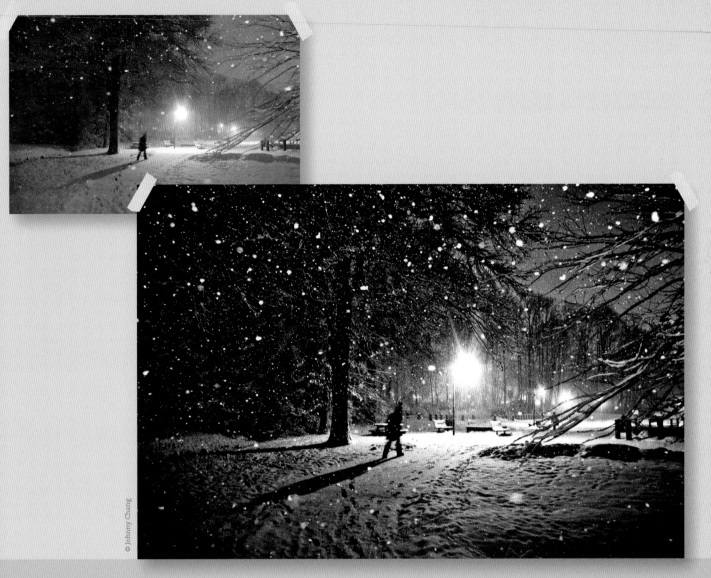

© Johnny Chang

The sodium vapor lamp robbed any semblance of color and added an unappealing tone, so I converted to black and white. To finish, I tweaked the tone curve, sharpened, added vignetting, split toned the highlights/shadows, removed larger distracting snowflakes and cropped a bit off the top of the frame.
Johnny Chang

The abundance of fine detail in this image, from the tips of the tree branches to the textured footprints throughout the snow, to the very snowflakes themselves, definitely calls for sharpening to bring it all to life. Crisp is the word, and turns the soft original into an engaging shot.
Michael Freeman

Noise Reduction

© Steve Luck

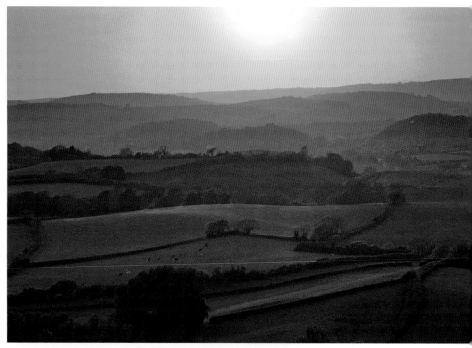

No doubt you're all too familiar with the issue of noise in digital images. Noise manifests itself as ugly-looking clumps of pixels and a graininess that is particularly apparent in larger areas of a single, flat tone. It's also more prevalent in shadow regions, and the problem is exacerbated at high ISOs.

There are two principal types of noise: luminance and chroma (or color). Luminance noise is likened to the static you see on a television station with poor reception—it is grainy and, if particularly bad, may appear as vertical or horizontal stripes (or bands) across darker areas of the frame. Chroma noise, on the other hand, appears as discolored blotches, and is usually more unnatural looking (and therefore more important to reduce).

With many Raw processors the noise controls are located directly beneath or at least near to the sharpening commands. This makes perfect sense, as the more you sharpen an image, the more apparent the presence of noise becomes. In most Raw-processing workflows, capture sharpening is swiftly followed by noise reduction.

As with sharpening, noise reduction has become increasingly sophisticated and effective as software algorithms have evolved. Even with the noisiest images, today you can often expect to end up with a usable image. All Raw processors offer noise reduction, but some have more controls than others.

← ↑ Too small to notice
Printed at this small size, the noise in this image may not be particularly visible (and it's worth bearing in mind that some print processes are very forgiving). However, the detail shown left clearly reveals there is significant luminance and color noise present.

← Chroma vs luminance
With Lightroom and Capture One, you have the option of tackling either the luminance or color noise individually, using the relevant sliders. Other Raw processors reduce both types of noise at once. If you have the option, I find dealing with color noise first makes it easier to judge the more subjective task of luminance noise reduction. Here, the Lightroom Noise Reduction Color slider was set to 50.

↑ Not-so-fantastic plastic
Having dealt with the chroma noise, it's time to look at reducing the luminance noise. It's tempting when reviewing an image at 100% to set a noise reduction value that eradicates the noise altogether. However, this will result in an unrealistic, plastic-looking image (seen above).

↑ A touch of texture
You want to retain some of the luminance noise as it gives the image an essential photographic textural quality. Here, the Luminance slider was set to 27, and the Detail to 85. The Detail slider provides a good way of fine-tuning the amount of noise left in the image.

↓ Ready for output
The finished image retains enough detail without including any obvious or distracting areas of noise, and can be printed at a much larger size as a result.

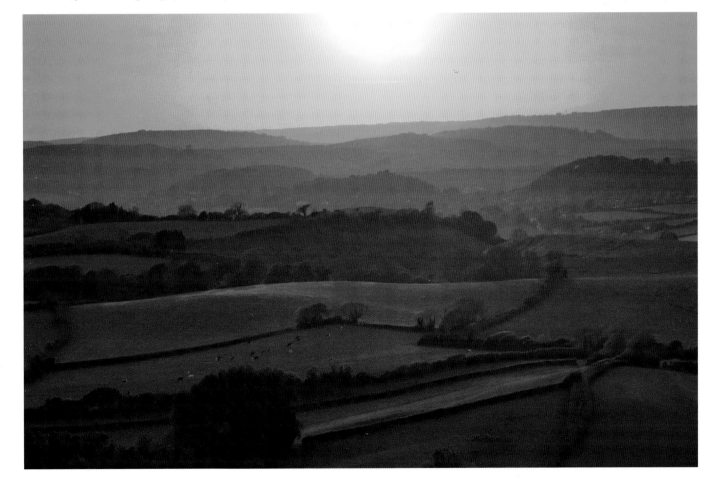

Clean Up a Noisy Shot

Challenge

↓ Low light, high noise

The high-ISO required to get this narrow-aperture, low-light shot may not be terribly obvious at first, but becomes readily apparent upon closer inspection. It's a fairly even balance between chroma and luminance noise, and definitely needs to be cleaned up before this image is ready for output.

If you're shooting with the latest and greatest camera gear, you may have great confidence in your camera's ability to shoot a clean high-ISO file; but this doesn't mean you never need to worry about noise. Far from it, if you're shooting Raw, you're still in charge of your noise reduction. Even if you tend to stick closer to your base ISO, subtle post-production work like

lifting shadows can often introduce noise where there was none before. This is another time when you'll want to zoom in close and inspect your images with a fine-toothed comb to see if they can benefit from a simple clean up. And with what you now know about noise, you may be able to go back in your archives and salvage a noisy shot that was thrown out.

←↖ Strike a balance

It's easy to get carried away with noise reduction—particularly when you're zoomed close in and losing the bigger picture of what the final, full image will look like. With a high enough setting on your sliders, you can indeed obliviate all the noise in most any shot; of course, you'll also be destroying all the fine detail. Here, the Luminance slider was slowly increased until the noise was low enough to not be seen at a normal viewing distance, but still high enough that the details in the trees still stand out.

Noise Reduction

Luminance		33
Detail		50
Contrast		0
Color		19
Detail		50

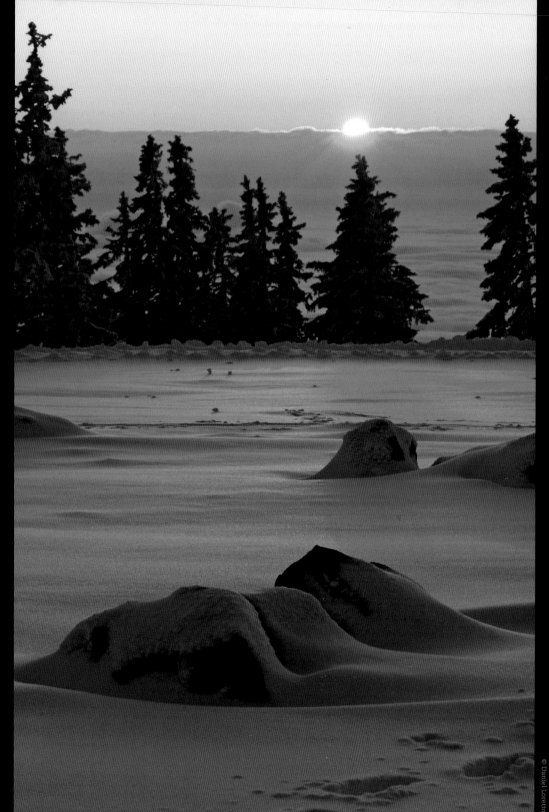

→ **Clean as the snow**
Just a touch of noise reduction salvaged this shot and struck a fine balance between texture and noise. There's still some luminance noise left in the shadows, but only if you zoom in very close, and it doesn't detract from the final image.

Challenge Checklist

→ Push yourself to shoot at a higher ISO than you're usually comfortable with, and see if you can clean it up to a degree with which you're happy.

→ Don't lose sight of the big picture—literally! Switch back and forth between a 1:1 magnification and a full-image view, and make sure your image doesn't take on too much of a plastic appearance.

→ Know when to call it quits. By all means, try your best to clean up a shot, but sometimes the end of the workflow is recognizing that there's simply too much noise in the image to make it presentable.

Review

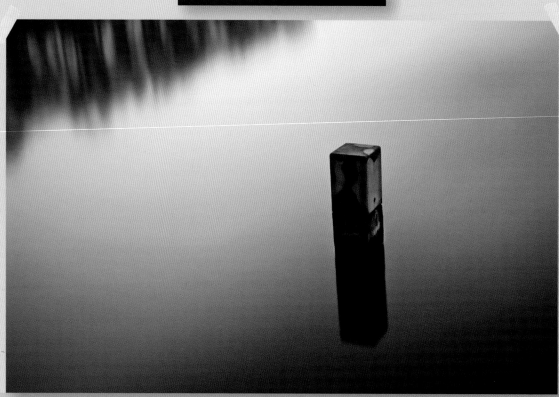

© Guido Jeurissen

This picture was shot at night, with a long shutter speed to make the water very smooth. In Lightroom, I started with changing the color temperature toward blue/magenta. Then I changed the lighting and contrast, and used the selective color adjustment tool to get the colors I wanted. After that I used to noise-reduction, with Luminance set fairly high and detail and contrast very low. After this I used a mask to make the pole sharper and brighter, as it had lost too much detail in the noise reduction. I finished it all off with a soft vignette.

Guido Jeurissen

I'm assuming that you did use the camera's noise removal option for fixed-pattern noise but that some still crept in over 2 minutes. The result looks perfect, and my only question is why you sharpened the pole afterwards rather than apply noise removal to a selection that excluded it.

Michael Freeman

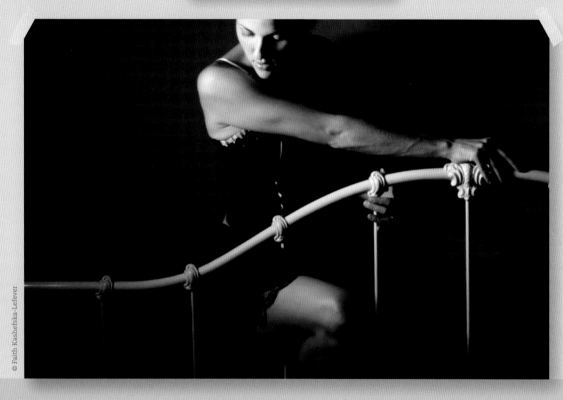

© Faith Kashefska-Lefever

I took this photo when I was just starting out. The light was low and my ISO setting was set high, resulting in a very grainy and noisy photo. Though some may like this effect, I wanted a softer look. Using the noise reduction tool in Lightroom, I set Luminance to 100%, which created a beautiful softness.
Faith Lefever

Like you, I find it hard to love noise in the same way that I could accept graininess in film, and this is an image that wants to be softer rather than gritty. Here's a good case of image editing coming to the rescue, but I guess you'll be avoiding the noise in the first place in future!
Michael Freeman

Advanced Image Optimization

If you shoot Raw it makes sense to perform as much optimization as possible in the Raw-conversion environment—not only can you make the best use of the camera's 12- or 14-bit unprocessed data when making adjustments, but any changes you make are nondestructive—which means whatever you do, the original image data remains untouched and constantly available.

Many of today's Raw processors are powerful image-editing tools in their own right—which is why many photographers now view them as fully-fledged post-production programs, and group them together with traditional image-editing software such as Photoshop, Photoshop Elements, and PaintShop Pro. In this section, we expand on the knowledge and techniques covered in chapter two and look in depth at the other tools and commands that can help you turn an unpolished Raw image file into a finished photo ready for output. Fine color-correction work, powerful black-and-white conversion, correcting lens distortion, and localized dodging and burning are all possible with Raw-conversion programs and are detailed here. Furthermore, having been built from the ground up with the photographer specifically in mind, you'll quickly discover that Raw editors are intuitive and easy to master. The section ends with two "real-world" examples, showing the typical steps that are taken when optimizing landscapes and portraits.

Tone Curves

A tone curve is a visual representation of the relationship between the highlights, midtones, and shadows in an image. Tone curves appear in the form of a graph, in which the horizontal X-axis represents the original tonal values (or input), while the vertical Y-axis represents the adjustments made to the original values (or output).

Tone-curve commands are found in a number of applications, both in Raw processors such as Lightroom and Aperture, and in post-production pixel-editing programs such as Photoshop, Photoshop Elements, and PaintShop Pro.

Tone curves provide a powerful and extremely versatile means of adjusting the entire range of tones present in an image by dragging points on the tone-curve line. Broadly speaking, the lower third of the line represents the shadows, the middle third reflects the midtones, and the upper third stands for the highlights.

By default, the tone curve forms a straight diagonal line (because no adjustments have yet been made, so each input value on the X-axis corresponds exactly to its equivalent on the Y-axis). Adjusting the shape of the curve alters the relationship between the various tones in the image.

© Steve Luck

←↑ Histogram overlay
This example of a default tone curve overlays the image's histogram—a graph representing the image's distribution of tonal values. Like the tone curve, the histogram moves along the horizontal X-axis from shadows, to midtones, to highlights.

←↑ Midtone brightening
Clicking on the central point of the line and dragging it upward will brighten the entire image, but primarily the midtones. Note that by dragging the curve, you pull up not only that particular segment of the curve, but also all the rest of the curve— which is to say, Curves adjustments are global, affecting the entire image.

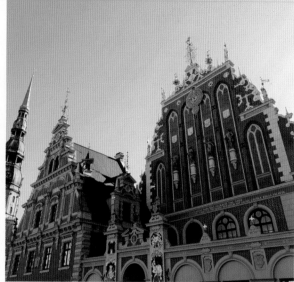

←↑ Midtone darkening

Clicking on the central point of the line and dragging it down will darken the entire image. Again, it is primarily affecting the midtones, but all other areas are also affected, with the adjustment gradually becoming less significant as you move away from the midtone areas.

←↑ The S-curve

A common curve adjustment is the "S"-shape curve. This is formed by clicking in the highlight region and moving the point up, while at the same time selecting a shadow point and moving it down. The resulting high-contrast image adds greater detail in the midtones, but loses detail in the highlights and shadows, which become brighter and darker, respectively.

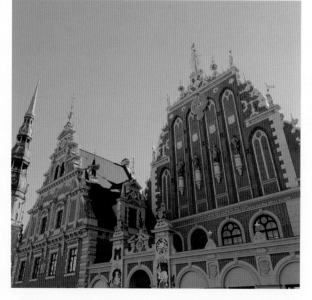

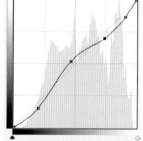

←↑ Multiple adjustments

Here, a highlight point has been selected to darken the highlights in the top right of the image, while other points have been added to create extra contrast in the rest of the scene.

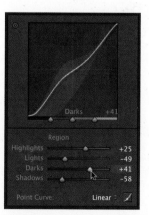

↑ Lightroom's Tone Curve

Here, this command also features sliders that can be used to alter the shape of the tone curve. This is helpful for users who aren't familiar with making adjustments via points on the tone curve.

Adjust Your Tone Curve

Challenge

↓↘ Chateau de Bonaguil
It's almost there, but highlights are a bit overexposed, and it's all too cold—the original scene felt quite a bit warmer in the setting sun. The first step is to pull down the highlights along the upper right of the curve, and then the blacks in the blue channel are selectively brought up to increase contrast and warm up the scene.

As it's a massively useful tool, and often one of the first adjustments you'll make to an image, it's time you start getting used to adjusting your tone curve. In many cases the tone curve will simply be a way to add contrast, lift your shadows, or pull back your highlights. In others, however, you'll recognize its usefulness for correcting color casts and controlling specific parts of your exposure in distinct areas of the frame. You will also quickly realize that a delicate touch is almost always a necessity, and that your curve needs to be treated and adjusted delicately—abrupt shifts or steep slopes and falls will result in bizarre and unappealing images.

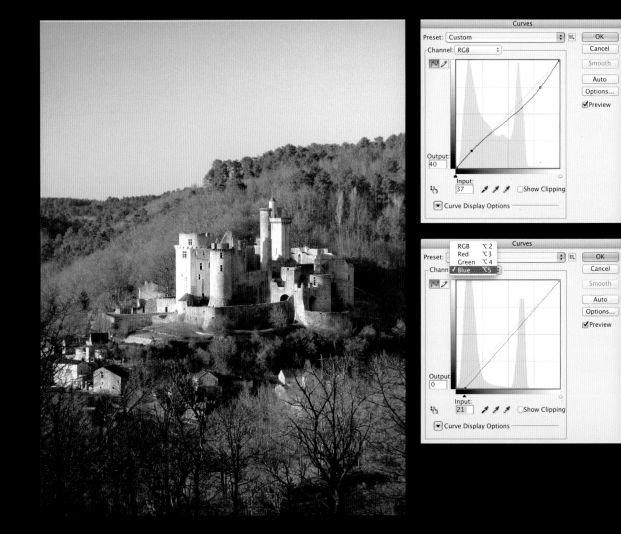

→ **2 steps and you're done**

While there are plenty of other methods that could have been used to tweak the color and exposure, curves is a one-stop shop for a number of your most common and useful adjustments. It's often wise to start with a curves adjustment, simply to see how much you can optimize the image in a single go.

Challenge Checklist

→ Make your curves adjustment first, before any other tools or sliders are touched. See how much you can get accomplished in this one powerful window.

→ You'll quickly see how sensitive your tone curve is to abrupt transitions— you'll need to plot your curve so that the arc never becomes too steep.

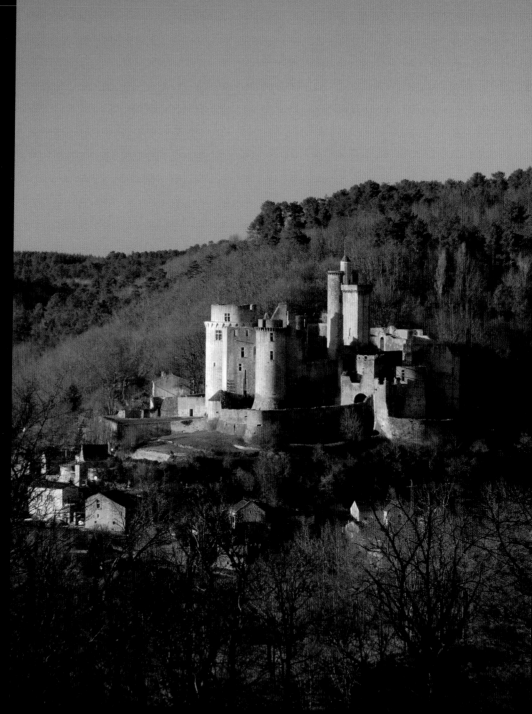

© Jim Jag

Review

© Faith Kashefska-Lefever

The only tool I used for this photograph was Curves. In the Curves adjustment window is an option with a hand and an arrow, by clicking that it allows you to adjust specific highlights and shadows directly on your photo. All I wanted to do was add some contrast to the wood, and then brighten up the label and highlights on the glass. To achieve that, I clicked on my background and dragged my curser down until I was happy with the results, and then clicked and dragged upward on the label to brighten it.

Faith Kashefska-Lefever

A classic example of how a generally flat and just not-quite-there shot can be brought to life with the right tone curve adjustments. The contrast helps the bottle and glass stand out from the wall in the background, and gives both the wood and the whisky a richer color. And Curves helps to retain that photo-realistic look.

Michael Freeman

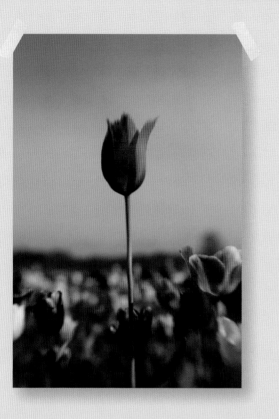

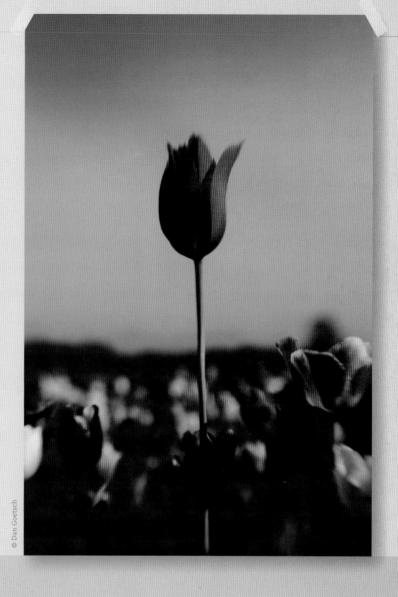

© Dan Goetsch

Shot with a fun lens called a Lensbaby—a manual-focus, tilt-shift-esque lens that can yield some interesting results—this looked pretty good straight from the camera, but I wanted to add a little drama. Curves allowed a quick edit by increasing the vibrance and making the shadows a bit more dramatic.
Dan Goetsch

The subtle Curves adjustment helps model the light around the main subject, and also obscures the rather busy background by dropping it out into shadow. Another instance where smooth curves adjustment looks more natural than would one of the local tone-mapping alternatives.
Michael Freeman

Color Correction

Having set the white balance and optimized the image's tonal values, it's likely that the colors are now pretty accurate (or at least appear so). However, there are a number of reasons why you may want to further adjust the colors in an image, ranging from a simple overall color boost to localized adjustments to a specific color.

Raw processors have sophisticated color-correction tools that allow you to adjust color in a variety of ways. Although the adjustment tools themselves may vary, Raw processors generally rely on hue, saturation, and luminance (HSL) to determine the source and target colors. Hue determines the color shift (wherein, for example, you can make oranges appear red, or blues appear purple). Saturation controls the color level (where you can specify how far from gray your color should be represented). Luminance darkens or lightens the color without affecting the hue or saturation.

↑ **Hue/Saturation/Luminance panel**
Rather than using the traditional primary additive (red/green/blue) and subtractive (cyan/magenta/yellow) colors for correction, Lightroom's HSL sliders utilize colors that are more meaningful to photographers.

↑↑ **Hitting the saturation sweet spot**
If you're shooting Raw, it's likely that the camera will produce images with muted colors, giving you the opportunity to add color in a more controlled way during Raw processing. Most Raw processors have a Vibrance as well as Saturation slider; both increase the overall color in the image, but the Vibrance slider works in a nonlinear way, increasing the saturation of muted colors before already saturated colors. This provides a more realistic color boost, and helps to preserve skin tones.

© Steve Luck

← ← Darker, richer skies

You can use the Luminance slider to darken any of the colors in your image. This works better than the Lightness slider in Photoshop (found within the Image > Adjustments > Hue/Saturation window), which tends to desaturate colors when making them darker. In this example we've reduced the luminance value of blue. This renders the blue sky darker so that the minaret stands out more. Used in this way, the color adjustment mimics the effect of a polarizing filter.

← ↙ Hue adjustments

Many wildflowers are delicately colored, and their color can change depending on whether they are photographed in sunny or shady conditions. If you don't have a gray card off of which to set an accurate white balance at the time of shooting, you may find flowers such as these bluebells are not quite the color you expected when you open the image. However, color control in Raw processors is sufficiently versatile to allow subtle shifts in the hue of specific colors. Here, a hue adjustment was made to the blue slider to obtain a more accurate color.

↗ → Lightroom Target Adjustment

Lightroom has a useful feature that allows you to edit specific and complex tones, such as that of skin. The Target Adjustment tool is activated by clicking on the small circle at the upper right of the HSL panel. Then, you can click and hold anywhere on the image, and by moving the mouse up or down, you will adjust only the sample in that particular area.

© Steve Luck

© Steve Luck

An excellent example of this tool's usefulness is in adjusting skin tones. In the top image, the skin tone is too pink. By clicking on the shoulder with the Target Adjustment tool, and dragging it upward, the oranges and yellows it samples are increased, thus reducing the overall red tint.

The Target Adjustment tool is not just restricted to the Color and Black and White panel; it can also be used to make adjustments to Tone Curves. It's a very useful way of identifying and making tonal corrections or adjustments to specific elements of an image.

Black-&-White Conversion

Another positive aspect of shooting digitally, and in particular when using the Raw format, is that when reviewing your images you're likely to find a few that potentially lend themselves well to a monochrome treatment.

Converting images to black and white at the Raw-processing stage utilizes the full 16-bit Raw data for maximum image quality; and as the conversion is nondestructive, you can revert back to color at any stage during the process should you so wish.

Raw processors utilize color sliders that allow you to adjust the tones in the black-and-white image once the basic conversion has been made.

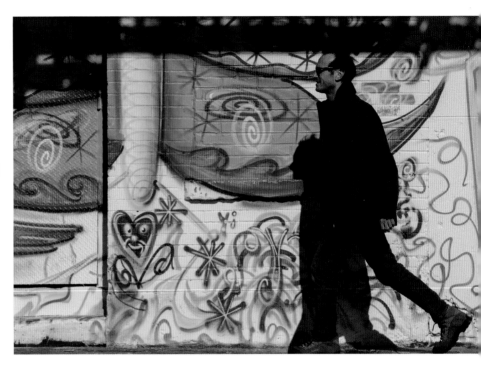

↗ An appropriate subject for B&W
This street shot of a man in profile passing in front of a colorful mural has an interesting composition, strong graphic qualities, and lots of different colors to play with.

→ Initial conversion
When you select the B&W mode in the Raw processor, the program uses the grayscale information in the red, green, and blue channels to create the black-and-white version. The Auto conversion is an accurate version of the color image, and is fine as such; but we can make more of an impact with some quick adjustments.

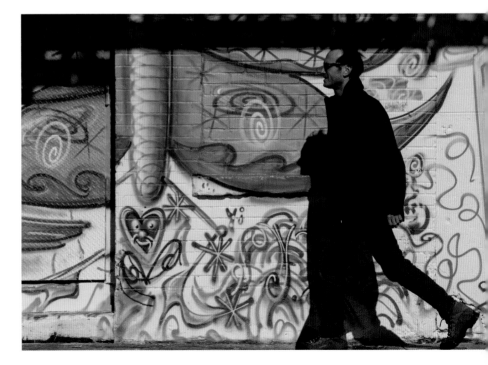

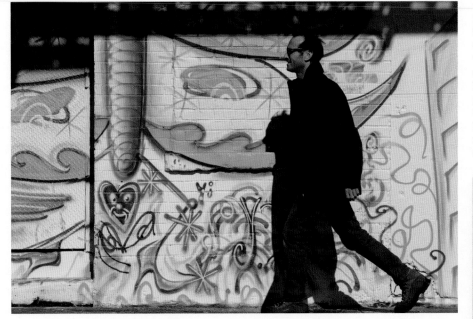

←↓ Selective luminance adjustments

Between his dark coat, his shadow, and the bold blue and red-orange on the mural behind him, the main figure is getting a bit lost in the dark. To enhance the contrast and make him stand out more, we can selectively brighten the colors behind him by using the Target Adjustment (upper left corner of the B&W panel below). Simply click on the colored area and, while keeping the mouse button pressed, move the mouse up slightly to brighten that particular color (or balance of several colors).

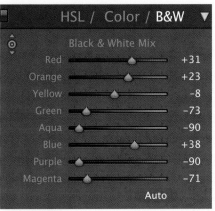

HSL / Color / **B&W** ▼	
Black & White Mix	
Red	+31
Orange	+23
Yellow	-8
Green	-73
Aqua	-90
Blue	+38
Purple	-90
Magenta	-71
Auto	

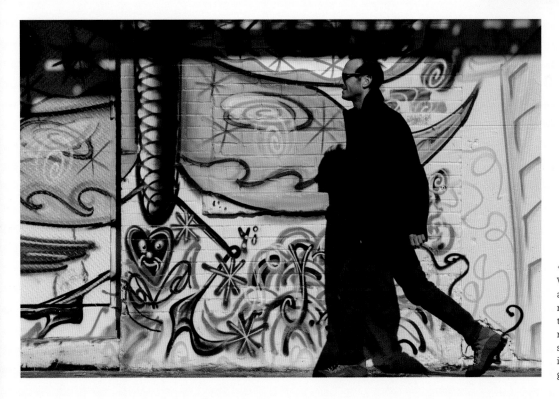

← Conversion complete

With the main figure now adequately pronounced, the rest of the colors are darkened to add interest throughout the rest of the frame. The finished shot has a classic street feel to it, and makes an excellent graphic statement.

Convert to Black & White

↓ ↘ Mountain vista
The bold, blue sky cast against the white snow, with foreground shadows in the river, all come together to make this a color shot with great B&W potential. The initial conversion, set to Auto, is quite conservative, resulting in a mostly gray image that doesn't really inspire. To add drama, the tones are pushed farther apart, upping the contrast considerably.

This challenge begins with finding a shot that has lots of potential for a black-and-white conversion. You're looking for something with contrasting colors—too much of the same tone and all you'll end up with is a gray image. Once you make your selection, you still have a lot of options in terms of how to render your subject in grayscale. If it's a portrait, you probably don't want to push your contrast too hard, and you'll want to keep your color sliders relatively close to each other. On the other hand, if you're going for a more dramatic look, see how far apart you can spread your tones in various parts of the frame for a final image that delivers a big impact.

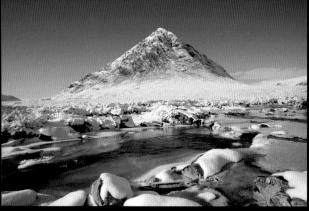

© JAC

Black and White

Preset:	Custom	OK
		Cancel
Reds:	-70 %	Auto
Yellows:	-22 %	☑ Preview
Greens:	127 %	
Cyans:	-92 %	
Blues:	-25 %	
Magentas:	-25 %	

Black and White

Preset:	Default	OK
		Cancel
Reds:	40 %	Auto
Yellows:	60 %	☑ Preview
Greens:	40 %	
Cyans:	60 %	
Blues:	20 %	
Magentas:	80 %	

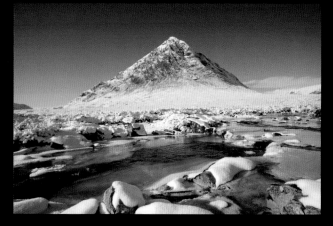

Challenge Checklist

→ Start by using your editing program's automatic conversion, just to set a baseline from which to explore other possibilities. You may also experiment with some of the presets.

→ Contrast is the name of the game, and you will have to decide not only how much or how little, but also where you want your contrast, and which tones best play off each other in grayscale.

→ Remember that you can specific colors to adjust by clicking and holding on that area of the frame, then sliding your mouse up or down to make your luminance adjustments.

↓ **Dark skies, bright snow**
The high-contrast final image, with the blue skies pulled into almost pure black, contrasting strongly with the bright whites of the landscape but complementing the foreground shadows, is bold, impactful, and effective.

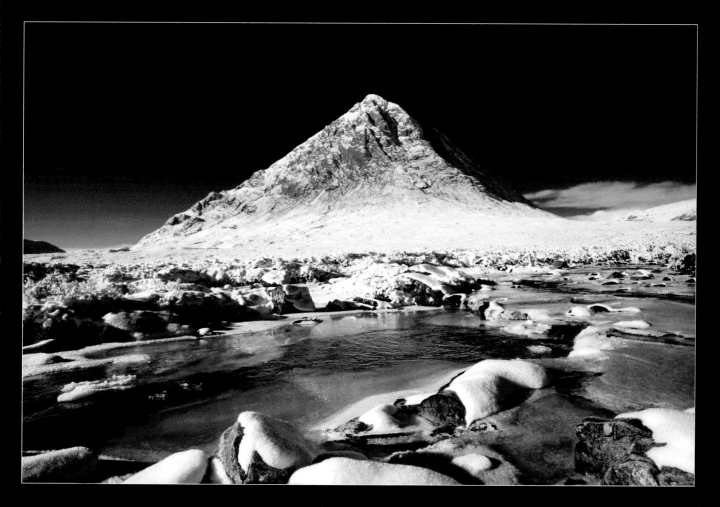

Review

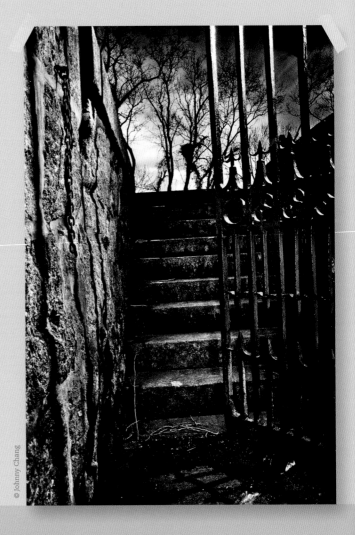

© Johnny Chang

The first thing I did was try to amplify my idea of casting the shadow of the gate onto the ground—my strobe was not strong enough in the daylight to do this. Then I played around with Curves and dodging/burning parts of the stairs and wall to get a frightening image that led the eyes up the stairs to what almost seems to be headless a zombie at the top. After that, I adjusted the blue grayscale mix amount to give a dramatic sky, and added a slight tilt to give it a more uncomfortable feeling.
Johnny Chang

It's extreme processing, but justified by your intention of making an unsettling image. The unexpected shadow certainly contributes to this (how far was the flash off-camera?). Good choice of method for darkening the sky at the top, which gives the image a tonal completion.
Michael Freeman

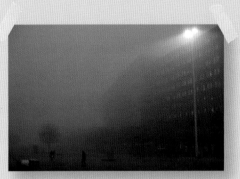

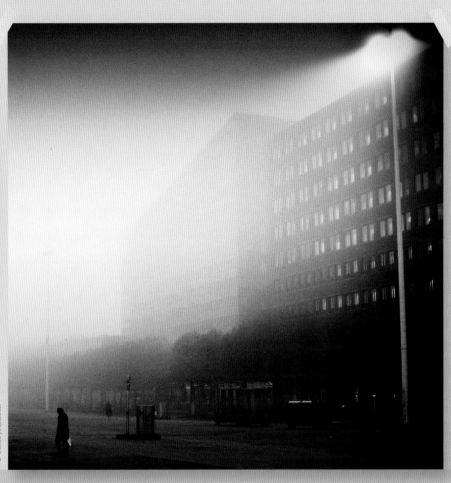

© Guido Jeurissen

I really liked the composition, so I scaled the image to a square frame to eliminate all the distracting objects in the periphery. Top right—the light; bottom left—the man. I liked it. Next I used the NIK Silver Effex Pro to convert the image to B&W. I played with the filters until I found one that I liked, added contrast and sharpness to make the walking man stand out more, then gave it some noise by adding an Ilford 400 film simulation. I gave it a custom vignette to finish it off.

Guido Jeurissen

Good composition and smart cropping at left to make a meaningful diagonal from the flaring streetlight to figure, with a clear contrast between the foggy distance and the grainy shadows along the bottom. Black and white concentrates the attention on the shapes and the man, with no distraction from the sky.

Michael Freeman

Lens Corrections

Despite the dramatic improvement in the optical quality of modern lenses, common lens issues such as pin-cushion and barrel distortion, as well as vignetting, are still widespread. Ironically, this is often the result of the very optical improvements mentioned, as manufacturers attempt to produce zoom lenses with ever-greater ranges in increasingly smaller sizes. Asking so much of a compact zoom lens is bound to result in distortions and aberrations at one or both ends of the range.

Fortunately, such lens issues are easily addressed in Raw processors, and in some cases are fixed automatically if the Raw processor recognizes the lens profile. If not, manual correction is straightforward, and you can save the changes to be made easily next time.

↖↑ Correcting chromatic aberration
This type of color fringing occurs when the lens is unable to focus the red, green, and blue wavelengths equally at the same point. Adjusting either the Red/Cyan or Blue/Yellow slider in the tool panel is all it usually requires.

↑ Pin-cushion
This type of distortion occurs most often at the telephoto end of a zoom lens, and is observed in straight lines bending in toward the center of the frame.

↑ Barrel
This distortion will occur mostly at wide angles, and is characterized by straight lines that bend out toward the edges of the frame.

↑ Straight, parallel lines
Both issues can be quickly fixed during Raw processing with the relevant controls (Distortion slider in Lightroom) or plug-ins. The image is properly corrected when straight lines run parallel to the edges of the frame.

© Steve Luck

© Steve Luck

↑↓ Reverse-vignette effect

Vignetting can also be used creatively to draw the viewer's eye to the subject of a picture. Usually corners are darkened and the shape and size of the vignette adjusted to best fit the subject. However, we can slide the Vignette control the other way to deliberately lighten the corners for a more dreamy effect.

↑↑ Fixing dark corners

Vignetting occurs when light is prevented from fully reaching the corners of the frame. It is usually caused by the lens barrel or lens hood, or by light striking the lens at an angle, and is most noticeable in areas of even tone, such as a blue sky, which will appear visibly darker at the corners of the frame. Use the Vignette control to lighten the corners.

Dodging & Burning

Dodging and burning is a well established photo-editing technique that dates back to conventional darkroom processing. The technique involves making local exposure adjustments to specific parts of an image to make that particular area brighter (dodging) or darker (burning).

When dodging in the darkroom, a piece of card is used to mask a specific area from the light of the film enlarger. The less light that strikes the photographic paper, the lighter the results. Burning involves making a standard exposure, and then further exposing those areas that are required to be darker, while masking the rest of the image.

Dodging and burning tools exist in Raw processors in the form of the adjustment brush, which can be used to selectively lighten or darken specific areas of the image.

← Select the skies
Select the adjustment brush and either select the Burn option or reduce the exposure setting of the brush. Zoom into the sky region and start painting over the clouds. You'll notice the clouds become darker as you paint over them.

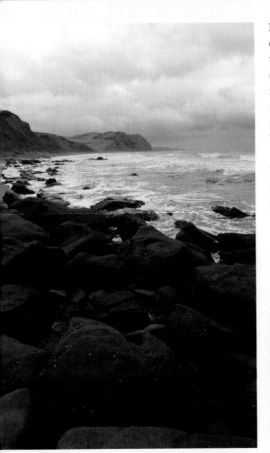

© Steve Luck

↑ Unadjusted original
Trying to achieve a balanced exposure without the use of a graduated neutral density filter in this scene has resulted in a sky that doesn't do justice to the glowering nature of the clouds, and foreground rocks that are underexposed. There are various options we can use to fix this, but one method that provides a good level of control is to use the adjustment brush to dodge and burn the exposure where needed.

← Mask overlay
All Raw processors, when using a selection tool, will allow you to view the selection as a color overlay. This is helpful, as it shows you exactly the areas that have been selected. Notice how the darker cliffs have been carefully avoided.

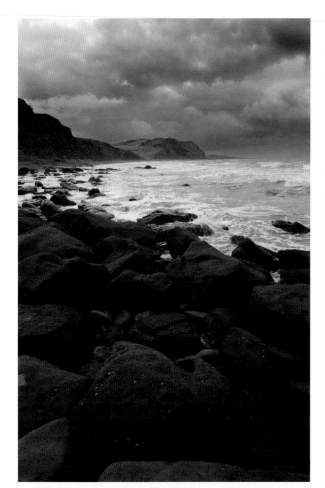

← Making morose skies

With the sky region selected, you can fine tune the exposure to whatever you want using the adjustment sliders. Here, we've reduced the exposure of the sky so that the clouds more closely resemble how they were. Once the proper exposure setting is found, press enter to clear the mask and make the adjustment.

↓ Converted to B&W

With the sky darkened and the foreground rocks brightened so that they draw in the viewer's eye, the final stage was to convert the image to black and white and sharpen it to ensure the textures stand out in stark relief.

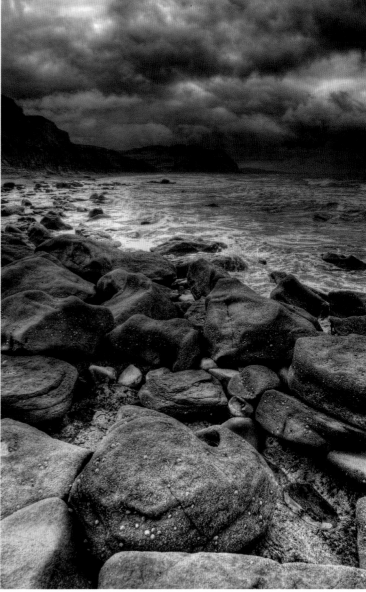

↑ Brightening the foreground

Next, repeat the process on the underexposed rocks. The Dodge brush was selected for this, but you can alternately increase the exposure setting of the adjustment brush—the effect is the same.

Optimize a Landscape

Over the next four pages we're going to look at how to optimize a landscape image (or, strictly speaking, a seascape photo in our case) using the techniques we've covered so far.

This is, of course, only one example and it is not intended to be the definitive way to optimize all landscape photos. However, many of the issues that commonly crop up do appear and are addressed here. As well as specific steps that you may or may not need to carry out, the order in which you carry them out may well vary from the order here. Much of this is down to personal preference as well as the individual image; but again, the optimization workflow here should work for most landscapes.

© Steve Luck

← Off the island of Corfu
This original seascape shows the attractive rocky coastline, clear blue ocean, and a near cloud-free sky. It's the sort of image that you'd find in a travel magazine or vacation brochure, but it needs some attention first.

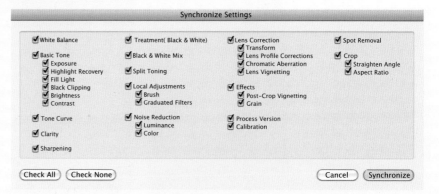

↑ Search the skies for spots
Before we do anything else, the first thing is to look for dust spots. Blue skies are notorious for revealing any spots on the camera's sensor, and if these are spotted by a stock agency the image (and in all likelihood any other images submitted along with it) will be instantly rejected. It's vital that you zoom right into the sky region and carefully survey it quadrant by quadrant. Whenever you find a dust spot, use the Spot Removal tool to delete it.

A useful feature of Lightroom and Adobe Camera Raw, and one that may roll out to other Raw processors, is the Synchronize Settings window. Using this function you can apply an adjustment, such as spot removal to one image, and have it carried through on other selected images, so saving quite a bit of time. Of course, if you are just removing the same dust spots from a series of different images, you wouldn't want to check all the boxes, as shown above.

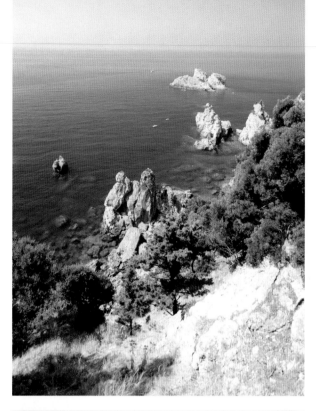

←↑ Lens profiles to the rescue

Having dealt with all the dust spots, the next stage is to fix the lens distortion issues. Our image has noticeable vignetting, and the barrel distortion at the wide end of the zoom lens is clearly visible in the curvature of the ocean on the horizon. The lens used, however, is a popular professional zoom and is recognized by Lightroom's auto Lens Corrections feature. As soon as the make and model of the lens are identified, the vignetting and barrel distortion is fixed. But fixing these issues manually would also have been a straightforward option.

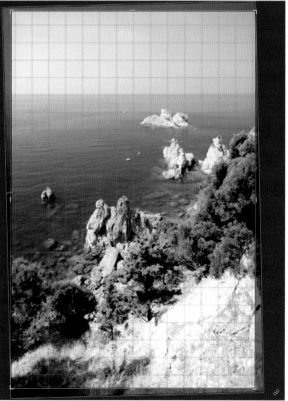

← Use the grid as a guide

Now it's time to straighten the horizon. There are a number of ways of doing this in Raw processors, but here we've simply selected the Crop tool in Lightroom and rotated the image at the corner.

↑ Highlight warning turned on

With the initial optimization complete, it's time to check exposure and overall tonal balance. With the sun behind, there's not too much of an issue with contrast. There are one or two places where highlights have blown and shadows filled in, but these are quickly fixed with the Highlights and Shadows sliders (or their equivalents in other processors).

Optimize a Landscape

↑↑ Burning the foreground
While the Highlights slider has fixed the overexposed highlights in the foreground, that area is still too bright. So the next step is to use the adjustment brush with a reduced exposure setting (i.e., Burn mode) to darken this significant area.

↑ Post-production filters
To give the sky a little more impact, rather than using the adjustment brush, we've used Lightroom's Graduated Filter tool. With the tool selected we simply click at the top of the image and drag downward to about a third of the way. We can then use the sliders to darken, lighten, add contrast or color saturation to the selection.

←↓ Add dimensionality
The final step is to sharpen the adjusted image. Again, to avoid oversharpening, always perform this step at a magnification level of 1:1. Only then should you back up and evaluate the final image.

↑ Making colors pop
With a graduated tint darkening the sky, it's time to use the Saturation/Vibrance sliders to perk up the color. It's tempting to go over the top with these adjustments, as color can be very intoxicating, but exercise restraint. If you think you've gone too far, you probably have.

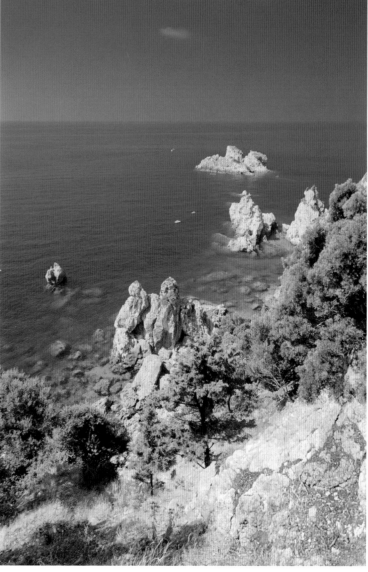

↑ Selective color adjustment
Even with a good boost of color, the foreground is still looking a little washed out. Using Lightroom's Target Adjustment tool set on Saturation, we can quickly add even more color to the dead grass, leaves, the sea and sky, and the green of the trees.

Freestyle: Optimize a Landscape

↓ Good, but not great (yet)
While the exposure for this snow scene was spot on (with slight positive compensation to ensure whites were rendered white instead of gray), it's fairly flat (low contrast), shows some vignetting, and the colors, while accurate, are a bit bland.

With all that you've learned about your Raw processor through this chapter, now it's time to apply your own particular recipe for image optimization to a landscape of your choice. You can tweak your curves and color, fix any aberrations or vignettes, or even try another black-and-white conversion. Experiment with different combinations of adjustments and see how they play off each other. Now, this does not mean simply going down the line of your toolbar and using every single image slider just because you can. Rather, the idea here is to recognize the right tools for the job and apply them correctly in order to achieve your own desired results.

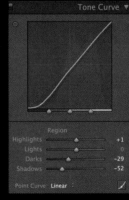

←↙↓ Five adjustments
Vignetting is cleared up easily in the Lens Correction panel, and a creative white balance is set at a cooler temperature than the original. A tone curve adjustment drops the shadows a bit darker while preserving the delicate highlights. And finally, the blue sky is both darkened and saturated to make it stand out from the slight blue hue of the snow.

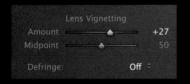

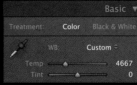

Challenge Checklist

→ This challenge is as much about self control as it is about exploring all your options. Just because a slider is there doesn't mean it's needed or even possible to use effectively for this particular shot.

→ Look at the big picture and consider what global adjustments can be made, but don't forget to then move closer and see if there are any particular areas or colors that need selective adjustment.

→ Don't forget the basics from the previous chapter: Inspect for dust spots, get your exposure and white balance spot-on, and ready your image for output with some noise reduction and sharpening, as needed.

↓ **Bluer and better**
A few simple adjustments took a fine but forgettable shot and elevated it to the next level. The end product wasn't necessarily expected from the start—only through experimenting with various controls and options did the potential of the finished shot gradually reveal itself.

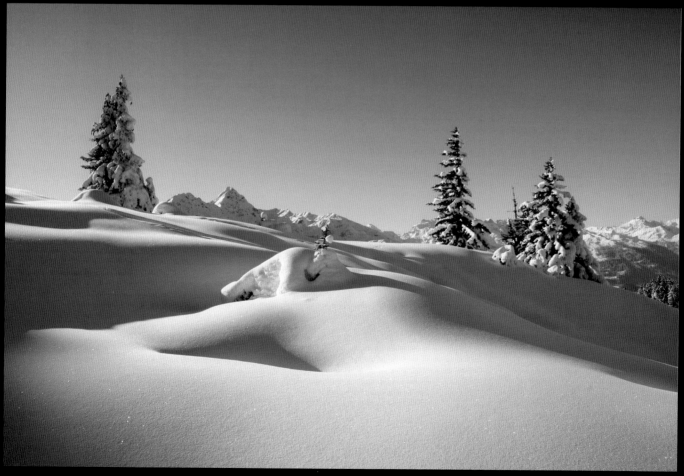

© Netzer Johannes

© Guido Jeurissen

This night shot required only very basic adjustments. I lined up the horizon, changed white balance, and added a vignette. All in Adobe Camera Raw.

Guido Jeurissen

Simple and straightforward—I like the enhanced yet still subtle new color palette, and brightening the sky nearer the horizon makes the scene more definite and engaging. The increase in contrast has the useful effect of a tonal vignette that draws the eye inward.

Michael Freeman

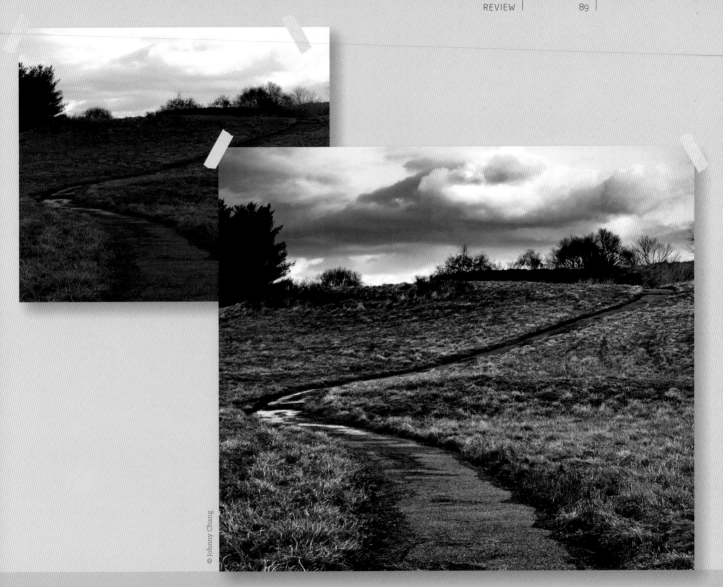

© Johnny Chang

First, I cropped the image to focus on the winding path. Then I brightened the image, did a highlight recovery, and added graduated filter to bring out the sky a bit. Next, I focused on getting a somewhat desolate look by adjusting curves, fill light, black level, and removing a lot of the vibrance/yellow color in the grass.
Johnny Chang

Excellent use of leading lines to pull attention into the frame, and the sharpening applied, while a bit heavy-handed for some (this is a matter of taste), is definitely gripping and noticeable—complemented nicely by the drama of the clouds.
Michael Freeman

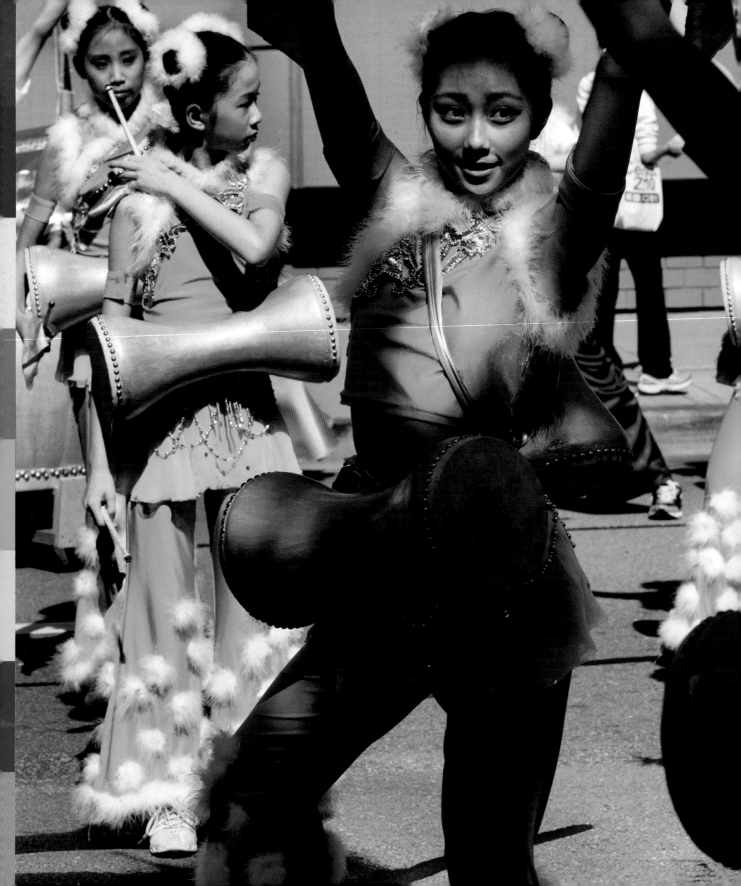

Image Retouching

This final section is devoted to "pixel-editing" post-production techniques using software such as Photoshop, Photoshop Elements, and PaintShop Pro. Although Raw-processing software has become increasingly popular recently, learning your way around pixel-editing software is still essential, as such programs can perform image-editing tasks that you simply cannot undertake with Raw-conversion software.

The section starts with exposure control using Levels and the more complex Curves command, before going on to explore how to adjust colors in your document. However, the real strength of pixel-based post-production software lies with layers. Put simply, layers allow you to combine various visual elements from different sources, and are therefore key to compositing. Closely associated with layers are adjustment layers. These allow you to make a whole host of adjustments, such as changes to exposure, color correction, or black-and-white conversion, and check them before committing finally to the amendment. The way in which layers in a document interact with one another is determined by blending modes. These are powerful algorithms that can radically alter a composite image's appearance, and many have practical uses in photography. For successful composites it's often necessary to make accurate selections of key elements of an image. A variety of selection techniques is covered here in detail.

The section ends with step-by-step instructions on a number of popular special-effects projects, including hand coloring, panoramas, and HDR imagery.

Levels

The Levels command is one of the key ways in which to adjust the overall tone in an image. Although it is not as versatile as the Curves feature (see pages 64–65 and 106–107), the Levels dialog is still one of the first places to go when post-processing an image (particularly if the image hasn't been through a Raw-processing stage).

The Levels command is centered around the histogram. Histograms are graphical representations of the tones present in the image. Running along the horizontal or X-axis are the tonal variations ranging from black at the left to white at the right, while the vertical or Y-axis represents the number of pixels with a specific tone. Histograms are an excellent way in which to quickly judge an image's tonal distribution, which is why they are available to view on almost all digital cameras, and why they are a key reference in all imaging programs.

The main function of an initial Levels adjustment is to set the black and white points, in other words to ensure that there are a good number of pixels that are both pure black and pure white. This, in turn, ensures that there are a full range of tones distributed throughout the image.

→↓ Low-contrast original
This image was shot under diffused natural lighting and the overall tones are flat and gray. The lack of contrast is clear to see in the accompanying histogram, which is displayed when you call up the Levels command (under Image > Adjustments > Levels in Photoshop). There are almost no pixels recorded at either the dark shadows (left) or bright highlights (right).

→↓ Setting the black point
Here we've clicked on the Black Point slider and moved it right to align with the left-hand group of pixels, darkening the image. Notice that the central Gray Point slider moves relative to the black slider. This indicates that the midtones are adjusting in proportion. If you notice a color cast in the deep shadows, go to the channel of that color in Levels. If the pixels are not closed up to the left, dragging in the Black Point slider for that channel only will neutralize the cast.

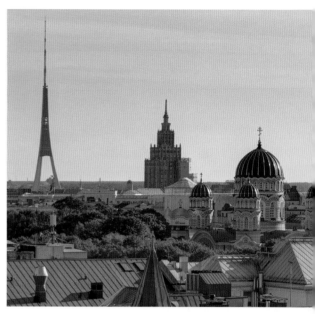

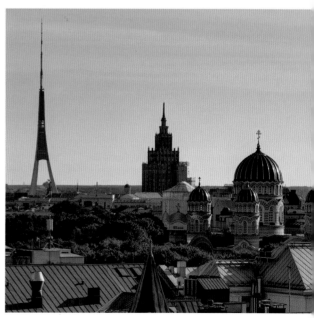

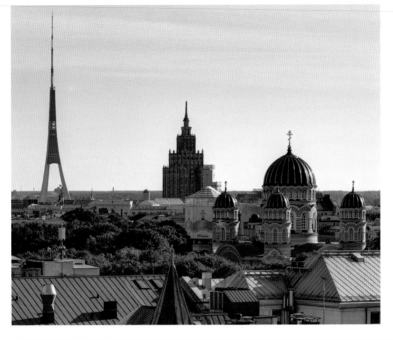

↑→ **Setting the white point**

The next step is to repeat the process, but this time with the White Point slider at the right of the histogram. Drag the slider left until it sits under the group of pixels at the right of the histogram. Again, you can hold down the Alt/Option key to show the parts of the image that will be clipped to pure white as you move the slider. This should also be kept to a minimum.

↑ **Updated histogram**

Once the black and white points have been set, if you close and reopen the Levels command, the histogram will then be refreshed to illustrate the new distribution of tonal values. Here, you can see that the image covers a greater spread of tones, and also has much more contrast because the shadows and highlights are farther apart.

→↑ **Midtone adjustment**

Although the image now has a full range of tones from white to black, the midtones are a little dark. This is easily addressed by moving the midpoint or gray slider left toward the black point so that more of the midtoned pixels are grouped at the white end of the scale. This has the effect of brightening the image. Moving the midpoint slider to the right would have the effect of darkening the midtones in the image.

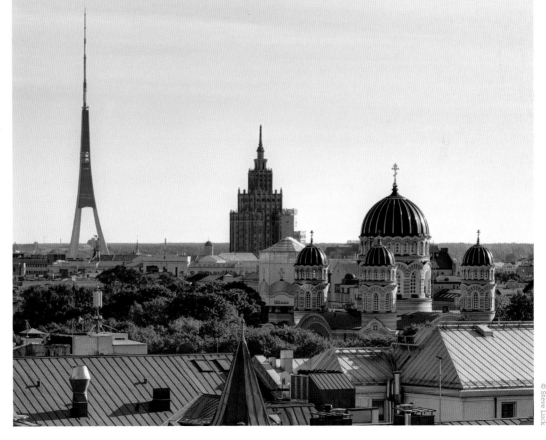

Challenge

Levels Adjustment

When it comes to essential adjustments to apply initially across the whole image, Levels is right up there with Curves in terms of importance and value; so it's time you start getting familiar with how to set your White/Black points and Midtones. Levels will be your first step for many shots, particularly those that feel rather flat and lack contrast. Such images often have a perfectly fine exposure, they just need the luminance information redistributed between the shadows and highlights. So for this challenge, pick a shot that may seem a bit ho-hum at first, and see how much impact you can give it while restricting yourself to only the Levels command.

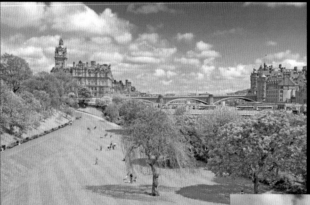

←↙↓ An Edinburgh exposure
This very bright image has a fine composition and plenty of detail in the highlights and shadows—too much detail, in fact. To make it a bit punchier, the highlights are pulled back just a touch, and the black point is set to 9, letting the shadows—particularly those under the tree at the bottom right of the frame—drop out and anchor the whole scene with some much needed contrast. Finally, the midtones are shifted every so slightly darker, resulting in a much more dynamic finished image.

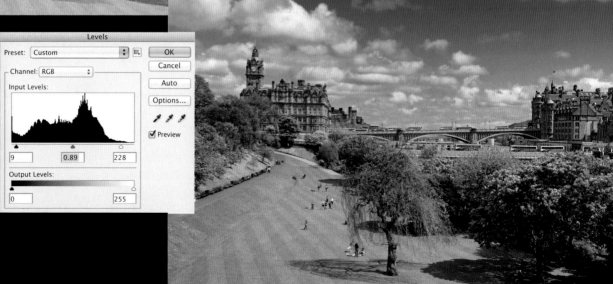

↘→ Pulling the shadows

This shot had to endure some overexposure in order to capture the glare of the sun (which is still slightly blown out—but in a way that works just fine in livening up the scene). Consequently, the shadows had to also be raised, and the resulting contrast is quite low. In Levels, the White Point is left alone, but the Black Point is set significantly higher, and then compensated for by pulling the midtones back toward the peak in the middle of the histogram. The finished shot is much more effective as a result.

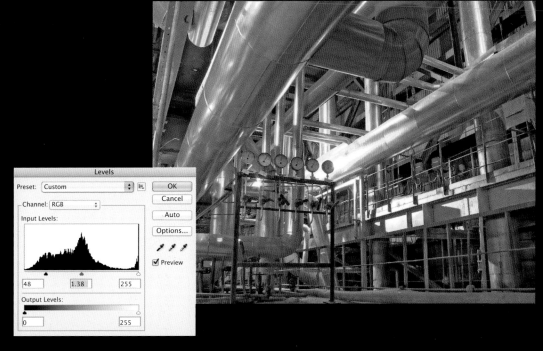

Challenge Checklist

→ Begin by looking at the extremes of the image: Are the highlights bright enough? Are the shadows dark enough?

→ Limit yourself to Levels, even if you know there is another, more familiar tool that could achieve your desired result. The point of this challenge is to recognize the potential of the Levels command, and explore how much you can achieve in this one single window.

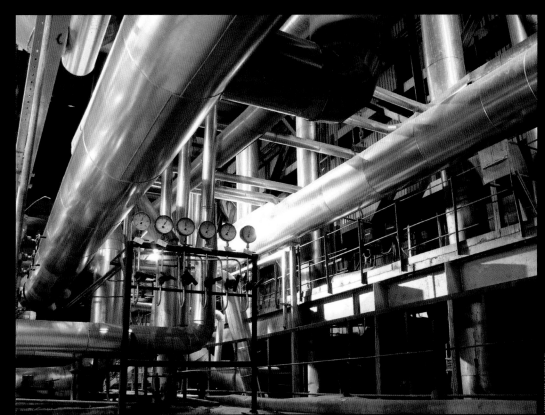

Review

© Dan Goetsch

Using Levels I brought some brightness and contrast back into this image. I brought the sliders back into the part of the histogram where the slopes started and evened things out. After that was done all that was left was to bring back a bit of the vibrance that was lost from increasing the brightness.

Dan Goetsch

Levels were a good choice for an image that contains no real tonal problems and for which center-weighted mid-tone adjustments will work perfectly. And it's good to use Vibrance rather than Saturation, as it protects against clipping.

Michael Freeman

© Johnny Chang

First, I dodged his face to see how much detail I could get back—it was very dark because there was no strobe at this angle (they were constantly moving around relative to my lights). I then cropped in to give tighter framing, burned some of the elements in the background that were distracting, and dodged parts of his leg and other areas that were not standing out enough from the background.
Johnny Chang

Yes, that was my first reaction—how you brought up the face and the T-shirt successfully. It's a well-caught moment, and careful processing makes it into an effective shot. It's also an example of how different procedures are often needed together—here, Levels plus dodging.
Michael Freeman

Curves

Although we looked at tone curves in the last section in relation to Raw processing, it's worth spending a little more time on the Curves command with our attention focused specifically on post-production pixel editors.

As discussed earlier, the tone curve represents the input and output values of an image's tones. Curves' versatility lies in the fact that unlike Levels, which only has black, white, and midpoint sliders, the line in the Curves dialog represents the entire tonal distribution, and it therefore provides a way of altering all the tones in the image. However, it's important to remember that as you adjust one point on the curve, other points on the curve are adjusted accordingly. You need to keep the tone curve as smooth as possible at each adjustment, as any abrupt change could lead to ugly posterization.

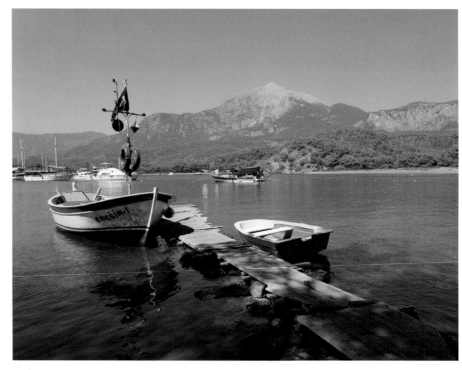

© Steve Luck

↑ Unprocessed and flat
This image was recorded in a Raw format and hasn't undergone any Raw processing. For this reason, it appears a little flat and lacking in punch. However, with three small adjustments we can inject more contrast, which will help boost colors and get the image to appear much closer to how the scene appeared in real life.

→ ↘ Pull down the sky
With most post-production software, you can use an Eyedropper tool on specific regions of the image to identify the corresponding tone on the tone curve. Here, the first thing we want to do is darken the sky. Clicking the Eyedropper there will reveal its position on the tone curve. In Photoshop, holding down the Cmd/Ctrl key while clicking will automatically add an adjustment point to the curve. Dragging the point downward will darken the tones in the sky. You'll also notice, however, that to keep the curve as smooth as possible, other tones and associated regions are also made darker.

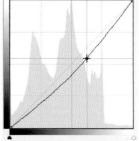

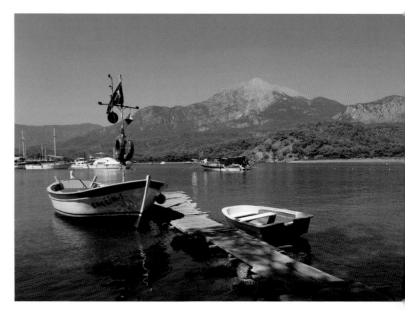

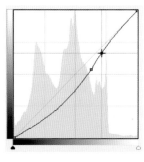

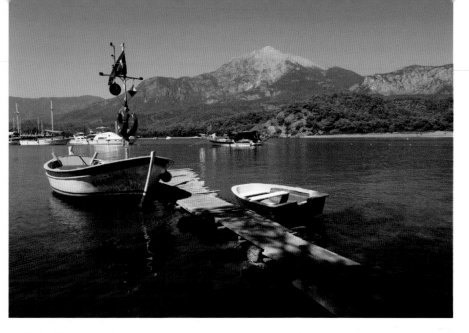

↖↑ Make the mountain pop

The next step is to brighten up the mountain so that it stands out against the blue sky. Again, we use the Eyedropper to create an adjustment point, but this time we move it up, back to its original position. This not only makes the mountain lighter, but the curve also automatically drops below the first point, further darkening the midtones and many of the shadows in the image.

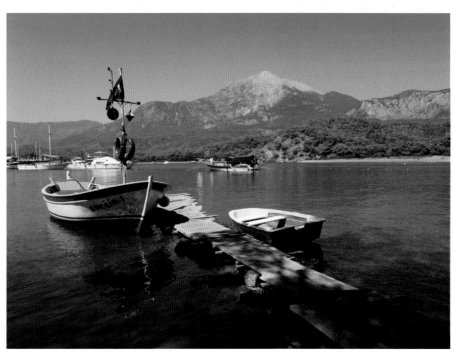

↖↑ Fix the shadows

Now all that remains is to lighten the shadows and too-dark midtones. We identify the tones with the Eyedropper and move the adjustment point upward, taking care to keep the curve as smooth as possible. In the final image, the sky is darker and bluer, and the mountain top creates greater contrast. But we've also managed to prevent the shadows becoming too dark.

Color Adjustment

Color changes in post-production pixel editors are made in much the same way as they are in Raw processors, in that colors are specified by their hue and saturation, as well as lightness (although this is called "luminance" in Raw processors, which as we shall see is significant). In addition to being able to adjust all the colors at once (for, say, an overall saturation increase), post-production editors also allow you to adjust individual colors—usually red, green, blue, cyan, magenta, and yellow.

As mentioned, where Raw processors and pixel editors can differ is that the former use a "Luminance" slide while the latter a "Lightness" slider. This may sound a trivial difference, but it is important. You'll find that reducing the Lightness value of a specific color in Photoshop, for example, will also desaturate the color rather than just darken it. To successfully darken a color in Photoshop without desaturating it you may need to experiment with all three sliders to get the result you want—for example, decreasing Lightness while compensating with a saturation boost.

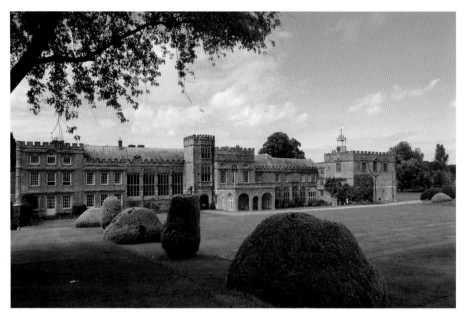

↑ Fresh from Levels, but lacking in color
This image of a former medieval monastery, Forde Abbey, England, has been tonally optimized using the black and white points in the Levels dialog, but the colors still look dull.

↙ Global saturation boost
Using the Hue/Saturation command to increase all the colors (Master) has definitely given the image a color boost, but the sky still appears a little washed out.

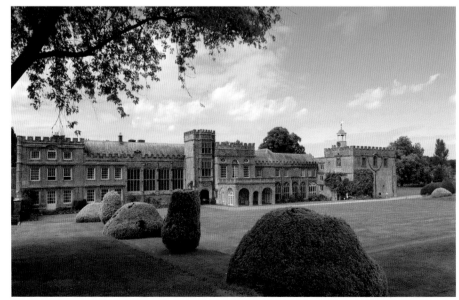

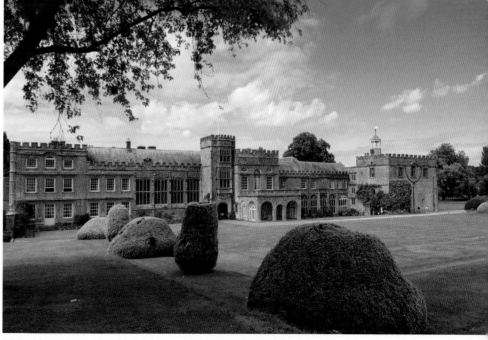

←↑ Selective saturation boost

To selectively increase saturation in the sky only, select Blues from the pull-down menu in the Hue/Saturation dialog and bump up the saturation until you're happy with the color. It's easy to overdo blue skies, to the point where they look quite unnatural, so use the preview button to switch back and forth between the original and adjusted preview, in order to best gauge its effect.

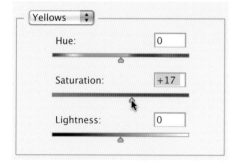

↑→ Add a touch of sunshine

Although this image was shot at the height of summer, that isn't particularly apparent. To add some warmth to the image, try increasing saturation levels in the Yellows.

© Steve Luck

Color Adjustment

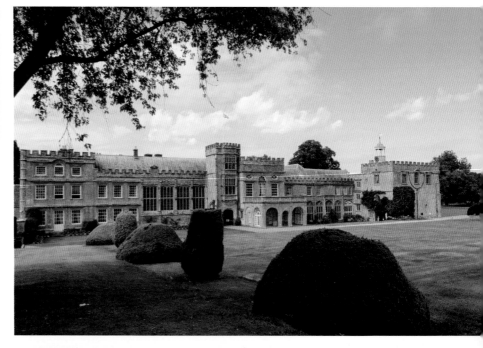

↑→ Colorization

Some of the image editors that have a Hue/
Saturation dialog also feature a Colorize button.
When selected, Colorize automatically turns
the color image into a monochrome one.

↑→ Experimenting in monochrome

Once the image has been converted into
a grayscale version, you can use the Hue,
Saturation, and Lightness sliders to set
a specific tone.

↓ Changing specific colors

As well as the Hue/Saturation control, which allows you to adjust all colors together or the primary colors individually, a number of programs have a Color Range or Color Changer control that allows you to be much more selective about the colors you want to adjust.

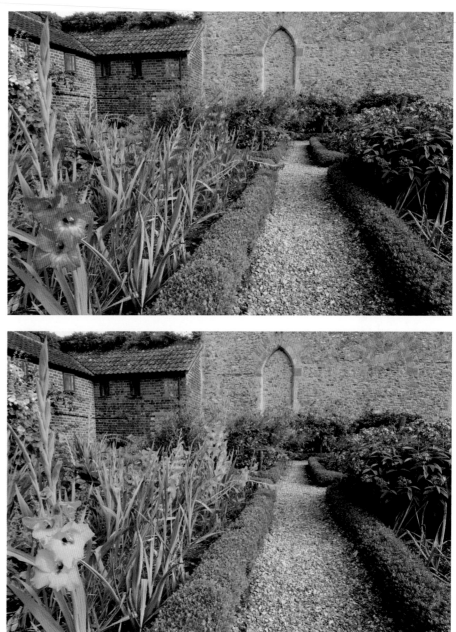

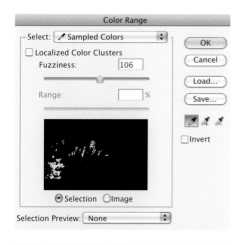

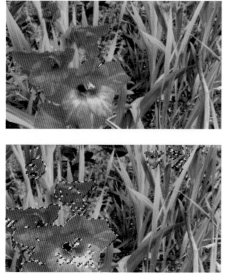

↑↑ Select a color

Find the Color Range/Color Changer command in your editing program, then use the Eyedropper tool to select the color you want to adjust. The dialog box allows you to set a higher or lower threshold to determine the extent of the selected color range. Only what appears white in the preview panel will be selected—the remaining black areas are left untouched. Below, you can see the dotted outline around the flowers, indicating the selection of that particular shade of red/orange.

↑↑ Red-to-yellow shift

With the gladioli flowers on the left selected via the Color Range command, I then opened the Hue/Saturation window and shifted only their color from red to yellow.

© Steve Luck

Challenge

Adjust Your Color

As an extremely subjective component of photography, color will always involve some creative decisions on your part. Indeed, your personal color preferences are likely to become a major component of your photographic style. Do you like bold, saturated colors, or a more muted, nostalgic effect? Which is more visually pleasing: a warm, glowing cast or a cooler one tending towards blues? Ask yourself these questions as you begin to explore your color adjustment options in this challenge. The particular image you choose to process will, of course, have its own unique demands. As usual, it's a mixture of visualizing what you want to achieve in advance, and then experimenting with other options along the way.

↓↘ Torii Gate, Miyajima

Like most sunsets, this image gives a lot of leeway in terms of how far you can go in your saturation levels. However, a straightforward global saturation increase mostly affected only the oranges and reds in this image, which isn't quite the intended look. In the Hue/Saturation (or HSL) window, only the yellows were selected, their hue was shifted so that they occupied more of the image, and finally they were selectively saturated.

Challenge Checklist

→ It's exceedingly easy to get carried away with your saturation levels— particularly if you've been staring only at HSL sliders for hours. So start conservative and move up from there. What seems edgy and impactful one minute might be revealed as simply gaudy the next.

→ Selective color switching is not only fun, it can be a necessary part of color management. Not all colors are created equal when captured by your sensor, so don't hesitate to adjust a particular color's hue if it doesn't represent the original scene as you remember it.

→ Don't forget the colorization option that is also offered by the HSL panel. Particularly if you are already considering a B&W conversion, colorization can be both fun and effective at communicating a certain mood or ambience.

↓ **Stronger and yellower**
The final image is now suffused in golden tones that, while not completely faithful to the original scene, do a much more effective job of creating an evocative look.

Review

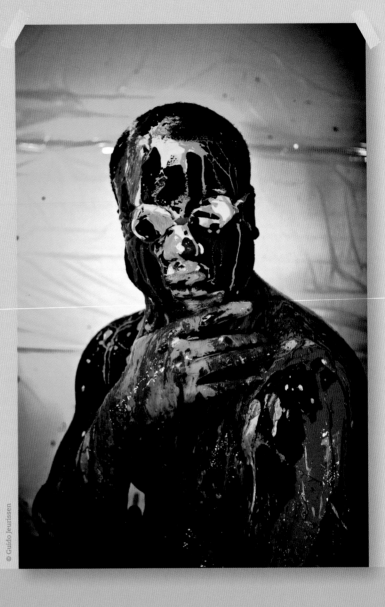

© Guido Jeurissen

I used two 800W halogen film lights (RedHead) fairly close to the subject to avoid shadows on his face. I shot at f/3.5 for a slightly blurred background. After white balance and sharpness adjustments, I used Lightroom to edit the colors. The HSL tab in gave me a lot of control over each separate color. I tried to make his skin as dark as possible, and the colors as bright as possible. Then I used split toning to make it a little bit cooler. It also gave the background a blue color, which I really liked.

Guido Jeurissen

That's a lot of work from your notes, yet the result, though vibrant, does not look over-cooked. I like the attention to detail in your processing, aimed at a well thought-through and obviously personal interpretation.

Michael Freeman

© Johnny Chang

Due to unmatched strobe lighting, I had turned my other shots to B&W; but for this one I wanted to bring out the team colors. I played with the fill light, black point, contrast, and vibrance, while reducing saturation. Then I selectively dodge/burned and cropped what I didn't want to be the focus, and added a sepia tone.
Johnny Chang

Definitely a good moment, and not one to be spoiled by the hot color of the lighting. Good choice of process in not only opening the pack of skaters up, but restraining the color so that the team shirts don't totally overwhelm the image.
Michael Freeman

Layers

Layers have been a feature of image-editing programs since 1994. These powerful tools allow you to create composite images made up of individual elements held on layers that can be "stacked" on top of each other, and which can be moved, resized, tonally amended, and so on—independently of one another, but also merged when necessary. You can also use Layers to enhance a single image, with adjustments applied to duplicate layers of the original. In this way you can optimize an image while leaving the original untouched—though this function has largely been replaced by Adjustment Layers (see page 110).

As nondestructive Raw-processing controls have grown increasingly more versatile, particularly in terms of the localized adjustments that you can now make with them, in some ways Layers have become less significant, at least in terms of "standard" photographic image editing. However, if you're looking to combine images to create a montage, for example, or replace one element of a photo with that from another, or add text or special effects, it's essential that you know how Layers work.

←↑ Beginning with two distinct images
Using these two shots—one skyscape of dusk over the Catskill mountains, the other a NASA model of the moon —we can make a simple layer-based montage to show how layers work and interact with one another.

A Layer thumbnail and name
B Visibility eye
C Blending mode
D Opacity slider
E Controls for adding new layers, deleting layers, adding effects, and creating layers masks

↑ Place moon on top

The first step is to make a selection of only the moon (dropping out the surrounding black) and place it in its own layer on top of the background. Then the moon is resized and positioned over the clouds at the right spot. The skyscape is also flipped horizontally for better composition.

↑ Layer reversal

Next, switch the layers to bring the clouds forward, and blend the two layers to weaken the moon.

↑ Touch-up

The cloud background is then duplicated and selectively brushed to strengthen the clouds until they appear to overlap perfectly.

↓ Massive moon

By combining these shots using layers, we're able to achieve a surrealistic shot of an enormous moon on the horizon. These same blending techniques are applicable to a wide range of potential composites.

Adjustment Layers

Just as layers can be thought of as comprising individual image components that combine together to make up the composite image, so adjustment layers can be considered as comprising individual image adjustments that together create the finished image. And just as layers are independent of one another and can be amended at any time during the creation of the composite image, so too are adjustment layers.

Although there are many similarities between layers and adjustment layers, they differ in one important respect: Layers contain image objects made up of actual pixels, just as in any digital image, whereas adjustment layers don't contain any pixels; instead they comprise the information that shows how the image will look when the adjustment is applied. The adjustment can be anything from a Levels or Curves command, to a Hue/Saturation boost, to a Dodge or Burn. This means that you can make and view any number of adjustments to the original image without altering the image itself. In this respect, adjustment layers are comparable to the nondestructive adjustments made during Raw processing.

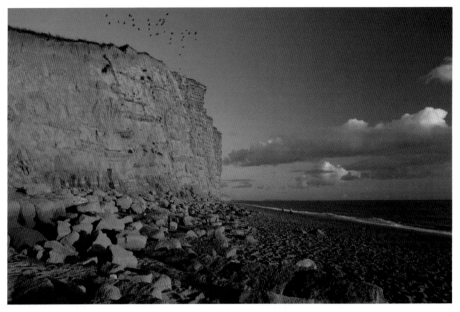

↑ **Sandstone cliffs**
This image of a coast in southern England has potentially strong colors, an attractive sky, and some pleasing graphic qualities. However, it's underexposed, lacks contrast, and the colors are initially a little dull.

↙↓ **Levels adjustment with an adjustment layer**
When you create a new adjustment layer (Layer > New Adjustment Layer) you'll be presented with the corresponding dialog. Here, we've created a new Levels adjustment layer to set the black and white points; the Levels adjustment layer will appear as a new layer in the Layers palette (below left).

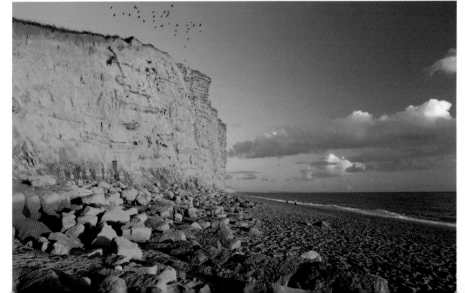

↑↗ **A second layer for contrast**

The next step is to add contrast by creating a Curves adjustment layer, and setting a characteristic "S" curve. Adjustment layers behave just like normal layers; you can use the visibility eye to gauge its effect, and even use the Opacity slider to alter the strength of the adjustment.

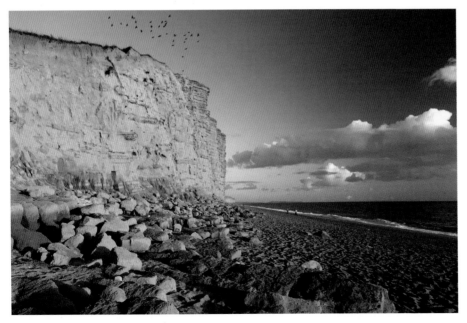

↑↗ **Finishing touches**

In our example, the last adjustment layer added was Hue/Saturation. In the Hue/Saturation dialog, I selected Red and reduced the Saturation setting; I then increased the Blue saturation. To finish, I double-clicked the Levels layer to bring up that dialog, and moved the midpoint slider to the left to brighten the midtones.

Challenge

Optimize with Adjustment Layers

↓ Neapolitan galleria
The wide dynamic range between the full daylight of the exterior (shining in through both the distant entrance at bottom right and giant glass dome above) and the shadowy interior storefronts made this scene overexposed and lack contrast.

Before moving on to some more advanced concepts, it's essential that you grasp how layers function and interact with each other. Adjustment layers are an excellent place to start, as they are using the same tools that you've already been getting used to throughout the book (Levels, Curves, Exposure, etc.). For this challenge, you should use a mixture of these tools to optimize an image of your choice, and use the adjustment layers to check their effect on the image as you move through your workflow. You'll likely find it a preferable way to make your image adjustments (it's much easier to click on the Eye icon than to repeatedly use the Undo command).

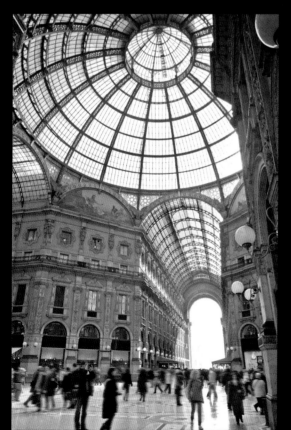

↓ Salvage the highlights
The first step is to try to regain some of the lost detail in the overblown highlights, so an Exposure adjustment layer is placed on top of the original background, and the overall exposure is reduce. A second adjustment layer uses Levels to set the white and black points, and slightly shift the midtones to compensate.

↓ Finishing touches
With the exposure set, two more adjustment layers are used to finish off the image: a Brightness/Contrast layer to boost contrast and add impact, and a Vibrance layer to selectively saturate the colors and liven up the scene.

→ Finished scene

With four simple adjustment layers, the image was transformed from a washed-out, overexposed scene to a dynamic and vibrant setting. And any number of refinements can still be made by simply going back to the relevant layer and tweaking the sliders.

Challenge Checklist

→ If your image editor doesn't already do so automatically, it's very useful to label your layers as you create them, to help you navigate through them and observe each layer's particular effect on the final image.

→ When you're ready to save your work, you will have the option of including all the levels in the file. This is helpful if you plan on revisiting and making changes to your edits, but if you consider the work finished, merge your layers and save as a regular TIFF or JPEG—it will be much smaller and compatible with other programs and websites.

© Samir Khadem

Review

© Guido Jeurissen

 I started editing this picture with a levels adjustment layer to set my Black and White points. I used Curves to light the midtones a bit and boost the blacks using a very subtle S-curve. After this, I lowered the Saturation and Hue, and gave it a greenish look by using the adjustment layer: Photo filter. Next, I exported it into Adobe Lightroom to remove some noise (I like Lightroom more with noise reduction). I finished it off with a custom vignette which is strongest at the top.
Guido Jeurissen

 I like the restraint, both in the tonal shading and in the reduction of color, which broadens the attention across the frame. The warm flesh tone and blond hair, while perfectly natural, would have drawn too much attention away from the equipment, which was important for the purpose of the shot (a fashion film-festival poster).
Michael Freeman

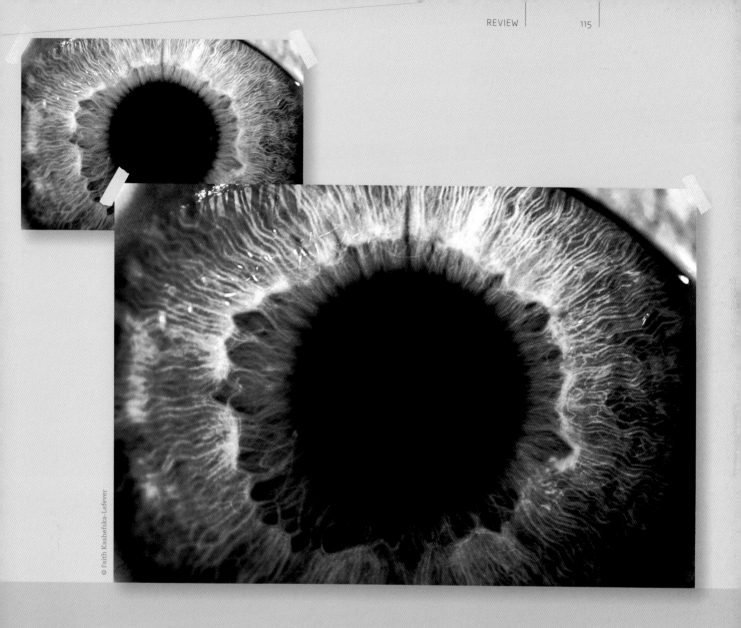

© Faith Kashefska-Lefever

My goal for this photo was to make the color and texture stand out. Using Photoshop, I duplicated the photo layer and set my Blending mode to Soft Light, knowing it would create more contrast and give the saturation a small boost.

Faith Lefever

That's an interesting and effective use of a Layer Mode to achieve a thought-through result, and do it very simply. A very striking, flower-like iris, and the only thing that niggles for me is the flesh-pink corner top-tight. But that's just personal.

Michael Freeman

Layer Masks

© Steve Luck

In the previous section on adjustment layers, you may have noticed the small white boxes on each adjustment layer in the Layers palette. These are called layer masks.

As we discovered when looking at dodging and burning, masks are used to control exposure to specific parts of an image by preventing light reaching the photographic paper. Digital layer masks work in a similar way: They are used to mask selected areas of the adjustment layer so that the layer below shows through.

Layer masks are a powerful and versatile tool that can be used for a variety of editing tasks, from simple dodging and burning, to selective coloring, to complex compositing.

↗ Unadjusted original

This image of classical and 19th-century marble statues is certainly underexposed and the statues don't stand out as much as they should against the dark background. I want to keep the background dark, but increase the luminance of the statues so that they appear almost to glow.

↑→ Start with a Levels adjustment layer

With this layer in place, I then set the black and white points to ensure the image had a good distribution of tones from black to white. This has resulted in a much brighter image overall but the statues still don't stand out from their backgrounds.

←↑ Selective masking

To fix this, I selected the Levels layer mask, and with a soft brush (set Hardness to around 50%) I began to paint over the walls. With foreground color set to black this has the effect of masking off the lighter Levels layer, so allowing the darker walls from the Background layer to show through.

→ Glowing statuary

In the final image, the Levels layer mask has produced a photo that combines the dark walls from the original image with the lighter statues of the Levels adjustment layer. With this combination, the statues now have the glowing effect I was looking for.

Layer Masks

Now we're going to use a layer mask to combine two images. This is a straight-forward example, but the technique demonstrates how more complex composites are created. Here, you'll see how using layer masks gives you real control over what is revealed and what is masked.

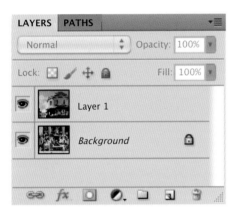

↑↗→ Two images, two layers
To start any composite or montage you need to copy and paste the various elements into one document. As you add new elements, a layer is automatically generated. Here, the Layers palette shows the two images we're going to use in this example.

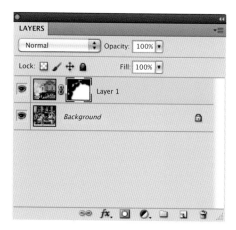

↑→ Add a layer mask

Unlike with adjustment layers, any new layer
that's automatically generated when you copy
and paste won't be given a layer mask. To add
a layer mask, select the appropriate layer and
click the Add Layer Mask icon at the bottom of
the Layers palette.

Having created the layer mask, again use a soft
round brush set to paint with black and start
masking out the top layer. This will reveal the
layer underneath, in our case the flower shop.

↑→ Fine-tuning

With the flower shop layer showing through,
we can fine-tune the layer mask by switching
the brush color to white and "painting back" the
top layer so that it follows the shape of the roof.
This is what makes layer masks so versatile. You
can switch between black and white as often as
you like to get exactly the mask shape you want.
Vary the size of the brush depending on the
level of detail you're working on, and use the
Opacity slider in the Layers palette to help you
see what you're trying to cover or reveal.

Blending

Blending modes are another powerful editing feature associated with layers. Essentially, they offer numerous ways layers can interact with one another based on the color and luminance values present in the images.

Many post-production image editors offer a variety of blending modes, and they are similar across the various programs. Blending modes have a vast number of photographic uses, too many to go into detail here; but the most useful are those that help to control and amend exposure, contrast, and color, and these are the ones on which we'll concentrate.

It's certainly worth spending time applying each blending mode to a couple of images to get a feel for what each does, but for now we'll take a look at some of the more common blending mode applications.

← Uneven underexposure
This image is underexposed, but more so at the bottom than the lighter sky at the top—a common photographic scenario. Increasing overall brightness using a Levels command would improve the exposure at ground level but result in a washed out or even overexposed sky.

↑ Blending mode
This pull-down menu is found at the top of the Layers palette in Photoshop.

←↑ Gradient layer
To address the exposure issue, create a new layer and apply a black/white gradient from top to bottom. With the blending mode set to the default Normal mode in the Layers palette, all you'll see on screen is the gradient.

↓↓↘ Fine adjustment

Although the street level is now much lighter and the sky is darker, there are elements at the top of the image, the building and spire, for example, that need to revert to the original exposure. To do this, add a layer mask to the Gradient layer and paint out the dark gradient. We can also reduce the effect of the gradient by reducing its opacity using the Opacity slider.

←← Blend in the gradient

If, however, you change the blending mode to Soft Light, the background image will appear, but you'll see that it has been altered by the gradient layer. The black of the gradient renders the top of the image darker, while the whiter area of the gradient renders the bottom of the image lighter—basically mimicking the look of a graduated neutral density filter.

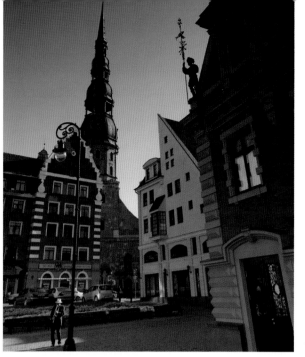

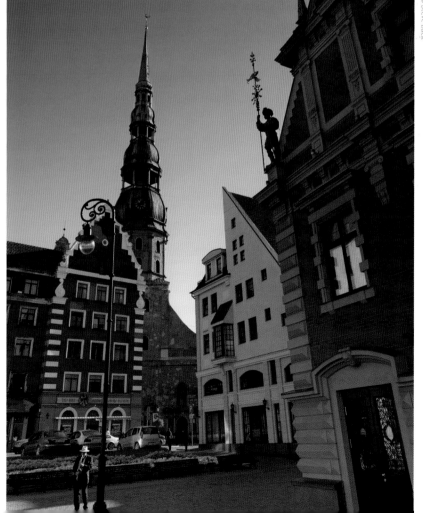

© Steve Luck

Blending

Here are some more useful blending mode options for photographers.

© Steve Luck

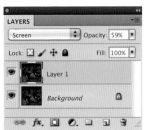

←↑↓ Multiply

This is one of the most commonly used blending modes. As the name suggests, this multiplies the colors of both layers together before dividing them by 255. Duplicating an overexposed image therefore, and applying the Multiply blend mode on the duplicate layer will have an overall darkening effect.

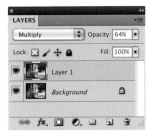

←↑↓ Screen

This blend mode multiplies the inverse of the colors of both layers. This has the opposite effect of Multiply. Duplicating an underexposed image and applying the Screen blend mode on the duplicate layer will lighten the image.

© Steve Luck

↑↗→ **Overlay**

In this example, the original image is lacking contrast and appears washed out. If we add a black-and-white adjustment layer, the image will initially turn monochrome. But change the blending mode to Overlay and the color returns. Overlay behaves like a combination of Screen and Multiply. Dark regions become darker and light areas lighter, thus boosting contrast.

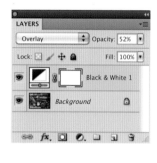

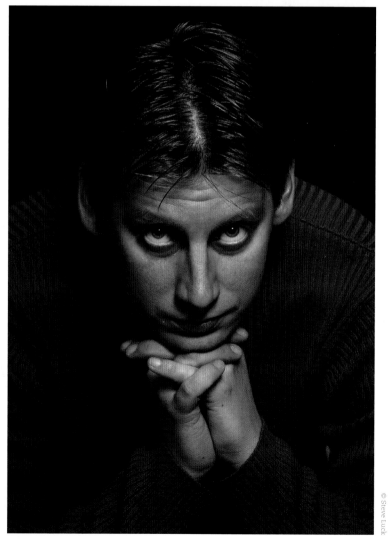

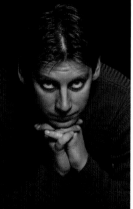

→→↘ **Color**

An alternative way of adding color to a monochrome image is to add a solid color layer (using the color picker to select an appropriate shade) above the background image. The screen will initially fill with the selected color, but switch to the Color blending mode and the monochrome image will assume the color of the upper layer. Use the Opacity slider to fine-tune the saturation.

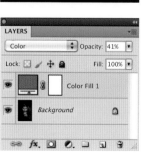

Making Selections

Being able to make selections accurately and quickly is a key aspect of many image-editing tasks, from simple image enhancement to more complex compositing and special effects.

There are numerous ways you can select specific parts of an image. These range from the simple manual selection tools (based either on shapes or freehand drawing) to the more complex semiautomatic tools such as the Magic Wand or Quick Selection, which rely on the hue, saturation, and lightness values of pixels to determine the selection. Within this latter category also falls the Color Range/Color Changer command that we looked at on page 103.

The real trick to making fast, accurate selections is to use a combination of the various approaches described here, and utilize the subtract and add options that accompany the tools.

© Steve Luck

↑↗ A simple ellipse
Post-production image editors provide a variety of shaped selection tools, the most common being rectangles and ellipses (including squares and circles). Click and drag with the mouse to make a selection of part of the image. Here, an ellipse was drawn around the model's head, the selection was feathered to soften the edge, and then copied and pasted onto a new layer for a quick vignette effect.

↙↓ Manual selection
As well as ready-made shapes, you can also make selections with a variety of freehand tools. In this example, a selection of the central underexposed region of this image was made, then feathered to soften the edge, before a level adjustment lightened the selected area.

© Steve Luck

© Steve Luck

Magnetic Lasso

If you want to make a more precise selection, and the subject contrasts clearly from the background, then the Magnetic Lasso is a good option. Simply draw close to the outline of the subject and the Magnetic Lasso automatically creates an outline selection using the contrasting pixel values to identify the edge. Click to manually add holding points. If you go wrong, hit Backspace to delete the point.

Magic Wand

This tool automatically selects pixels that share similar color and brightness values. Hold down the Shift key to add to the selection. The Magic Wand is perfect for selecting large areas of flat or near-flat color, such as skies. Here, the sky has been selected and saturation increased using the Hue/Saturation command. You can adjust the Tolerance setting to increase or reduce the color range the tool selects.

Composite options

When shooting with compositing in mind, photographing elements against a white background makes it easy to cut them out later using the Magic Wand tool. Remember that if you want to select the subject of the picture and not the background, select Inverse before copying the selection.

© Steve Luck

© Steve Luck

Making Selections

© Steve Luck

One of the most sophisticated selection options is Photoshop's Quick Selection tool. This works in much the same way as the Magic Wand tool, in that it analyzes color and brightness values to decide what should be included in the selection and automatically finds contrasting edges.

The Quick Selection tool is extremely easy to use, and when used in conjunction with Quick Mask (as here) or with the Refine Edge option (see page 129) it can produce accurate cut-outs very quickly, particularly where soft edges are involved.

In this example, we're going to employ the Quick Selection tool to make a cut-out of these two horses.

↑ **Add to selection**
To start, choose the Quick Selection tool and begin painting over the subject you want to select. The default selection brush is the "add to selection" option. As you paint over the subject, the tool analyzes its pixel values and adds similar pixels to the selection.

↑ **Subtract from selection**
There are likely to be times when the tool will make an erroneous selection or two. Change to the "subtract from selection" tool in the Options bar, or simply hold down the Alt/Opt key. The + symbol in the brush circle will turn into a – sign. Brush the area you want to remove.

↑ Switch to a Quick Mask

Once the selection is complete, depending on the subject matter, you can either carry on with the compositing, or as is the case here, we're going to switch to the Quick Mask mode by clicking the icon at the bottom of the toolbox. This puts a red mask over everything that hasn't been selected, and allows us to fine-tune the selection before finalizing it.

↑ Fine-tune with a paintbrush

In Quick Mask mode you can add or subtract to the mask by using a paintbrush to paint with black or white. Painting with white removes the mask, in other words it adds to the selection. Here, we're painting out the mask that covers some of the horse's mane. We'll also need to paint farther down the horse's head along the right side. Reducing the opacity of the brush in the options bar makes the mask semitransparent; this is helpful when you need a soft edge to the selection, as here with the horse hair.

↑ Zoom in for fine details

Painting with black adds to the mask, thereby subtracting from the selection. Using Quick Mask is a very effective way of fine-tuning a selection. You can use the X key to switch rapidly between black and white on the paint brush so that adding to or subtracting from the selection is quick and easy. In addition, because you're using the brush tool to tidy up the mask you can alter the size of the brush depending on the level of detail you're working on. For really detailed areas, zoom right into the image and use a small brush.

↑ Cut-out complete

Making an accurate cut-out of the two horses using a combination of the Quick Selection tool and Quick Mask took a matter of minutes, and the mask enabled us to accurately retain the soft horse hair within the selection.

Making Selections

For exceptionally accurate selections, particularly where the subject is difficult to distinguish from the background, and where you want to keep a hard edge, by far the best selection method is the Pen tool.

The Pen tool utilizes Bézier curves to create outlines, called "paths," around complex shapes. The paths can then be turned into normal "marching ant" selections. Although initially difficult to master, the Pen tool offers maximum control and smooth, clean results.

↑ Drawing with the Pen tool
The Pen tool essentially works in two ways. To draw straight lines, simply click on a starting point. Release the mouse and click on the next point and a straight line will be drawn. If, however, you click and then drag with the mouse, direction handles will appear. These control the shape of the curve.

© Steve Luck

↑ Follow the pixels
Before using the Pen tool to create a path, zoom right into the subject so that the outline is visibly pixelated. Click at a suitable starting point. Click at another point on the edge, but don't let go of the mouse. Rather, drag the cursor and the direction handles will appear. Move the handle to fix the shape of the curve to the outline. The longer the handle, the longer the curve. This will take practice.

↑ Move on to the next point
With the second anchor point placed, hold down the Alt/Opt key and click on the second anchor point. This will delete one of the direction handles. You can now place the third point. If you wanted to continue with the shape of an existing curve there's no need to delete the direction handle, simply click to create another point.

↑ Hug the edge
A good tip is to drag the direction handle in the direction you want the path to follow. If you do this you'll notice that the curve will come close to hugging the subject edge. If at any point you want to reposition an anchor point, hold the Cmd/Ctrl key and click on the point. You will now be able to move the point (and the previous path) to any position you wish.

↑ Complete the path

To delete a newly made anchor, simply hit Backspace. When you come to the start of the path, a small circle will appear next to the cursor. Click and the outline path will be completed.

The selection of the statue as viewed with the On Black option in the Refine Edge View Mode.

Photoshop also features a powerful selection tool called Refine Edge. Once you've made a selection using any of the selection tools, you can use Refine Edge to tidy it up. What follows are some of the more important options.

View Mode allows you to review the selection in a variety of display modes.

Refine Radius and Erase Refinements helps you to select and fine-tune a selection that features soft edges. This is the best option, for example, if you want to make a cut-out that includes hair.

Edge Detection/Smart Radius will automatically adjust the selection depending on whether the edge is hard or soft.

Adjust Edges features a number of manual controls that allow you to Smooth and Feather the selection, while Shift Edge allows you to increase or decrease the size of the selection.

Output determines how the selection is to be saved.

←→ Ready for compositing

Once you've completed the path, click the Path selection tool to reveal all the anchor points. You can reposition any of these points by holding down the Cmd/Ctrl key. When you're happy with the path click the Load path as selection icon at the bottom of the Paths palette.

Removing Unwanted Objects

Along with making selections and cut-outs, removing unwanted objects from photos is another common post-production image-editing task.

There are innumerable reasons why you might want to delete objects from a photo, whether it's a sign emerging from someone's head or, as is the case here, cables running in front of a building.

Although there are ever-more sophisticated cloning tools and algorithms available, such as Photoshop's Content-Aware option (which is certainly worth trying), you're still likely to have to turn to manual cloning at some point to get the precise result you want.

↑ Healing brushes
If you have a healing brush option, it's certainly worth trying it where you can. Photoshop has two healing brushes: the Spot Healing Brush, which automatically attempts to replace the selected object with pixels of a similar color and brightness value located nearby; and the standard Healing Brush. With the latter you have to sample a source before the tool works.

↑ Spot Healing Brush
With Content-Aware set in the Options bar, this has done a good job of replacing the cables in the sky, but look closely at the side of the building and you'll see that the tool has created two darkly colored blurred areas, where the cables pass in front of the building.

← Cluttered with cables
In this example, we're going to use a variety of tools to remove the cables and lamp from this otherwise attractive image of a church.

↑ Clone Stamp
As the area that we need to fix is uniformly patterned, we can't use any auto healing options. Instead, we turn to the Clone Stamp tool, and sample the edge of the building by holding down the Alt/Opt key.

↑ Follow the edge
With the area sampled, simply click on the affected region, ensure it's aligned accurately, and replace it with the unaffected area that we cloned earlier. The Clone Stamp tool works best with a soft brush—a hard brush may result in visible edges. It's also worth experimenting with the Opacity setting in the Tool Options bar. A setting of around 50% means you have to click a few times for the cloning to complete, but it does afford a level of control.

↑ Keep it aligned
Keep the Clone tool on the default Aligned option. This ensures the source point moves with the brush as you clone over affected areas.

↑ Easy cleanup

If you're cloning straight objects, such as this cable, select a source point as usual, click to clone away the cable, but hold down the Shift key. Click at the end of the cable and the tool will automatically replace the entire length of cable.

↑↗ The Patch tool

There are number of ways you could remove this lamp. Photoshop's Content-Aware Fill option would do a good job, but here we're using the Patch tool. In Source mode, make a selection of the lamp, then move the selection to a source area and release the mouse. The tool will automatically use the source area to replace the lamp. When replacing such a large object in one go, you'll need to tidy up after with the Clone Stamp tool.

← Uncluttered

The finished image, free of distracting and ugly cables.

↑↑↑ Larger brushes for faster work

Don't be afraid to increase the size of the Clone Stamp tool brush when cloning regularly patterned areas. As long as the alignment is true, the cloning will look natural.

© Steve Luck

Retouching a Portrait

Here, we're going to optimize a portrait. As with the section on landscapes, this is certainly not the definitive optimization route for all portraits, as much depends on the style, content, and quality of the original capture. However, as before there are common issues here, and the optimization tools that we use are commonly used to retouch and improve portraits.

It's worth pointing out that portraits require a different approach than many other subjects, as we tend to have preconceptions and expectations of the way in which a human face is represented that aren't applicable to, say, a landscape. For instance, whereas you want to render a mountainscape as sharply and vividly as possible, with portraiture, sharpness and saturation often need to be scaled back, as they can bring out imperfections and blemishes, and render delicate skin tones as artificial and unflattering. Needless to say, it's best to use a light touch when editing a portrait.

→ **Original shot**
Having got the composition just fine for a natural-looking portrait, the first step is to give it a close look to see where improvements can be made. For one, there are a few skin blemishes that can be removed easily enough. And beyond that, the creases by the nose and mouth can also be taken out to take a few years off the model for a flattering effect.

←↙ Spot Healing Brush

At the upper right of the model's forehead is a small blemish surrounded by "clean" skin. In these cases, a simple click over the blemish with the Spot Healing Brush will automatically replace the selected area with clean samples from nearby areas.

→↘ Healing Brush

Where blemishes are closer together, the Spot Healing Brush is less useful—in this case, it might sample the strands of hair and duplicate them over the blemish. To avoid this, select the Healing Brush and take a direct sample from a separate clean area.

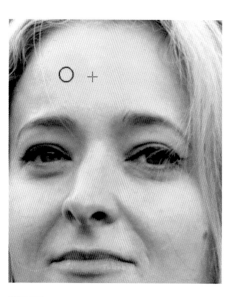

■	⬚ Spot Healing Brush Tool	J	
	🩹 Healing Brush Tool	J	
	▦ Patch Tool	J	
	+👁 Red Eye Tool	J	

	⬚ Spot Healing Brush Tool	J	
■	🩹 Healing Brush Tool	J	
	▦ Patch Tool	J	
	+👁 Red Eye Tool	J	

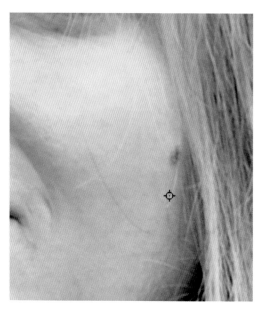

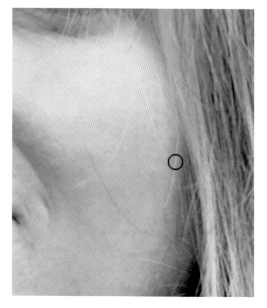

←←↙ Clone Stamp tool

In cases where the blemish is obscured by a detail—in this case, another strand of hair—the Clone Stamp tool is often a better choice. Simply select a point farther down the strand of hair to copy, and then paste that selection onto the blemish, lining up the strand to match the surrounding area.

■	🔨 Clone Stamp Tool	S	
	🔨 Pattern Stamp Tool	S	

Retouching a Portrait

 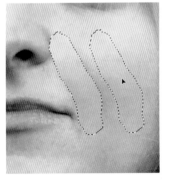

↑ ↑ ↗ **Patch tool**

Now to take out the creases by the nose and mouth. The Patch tool makes this a simple task: Select the area surrounding the crease, then move it over an unblemished area of the cheek. The cheek area is then used to "patch" over the target, resulting in clean and smooth skin tones.

→ **Optimization complete**

The finished portrait now has a more professional quality to it, with no distracting blemishes, and even some digital plastic surgery to reverse the aging process by a few years. As this is not a high-fashion shot, a few stray strands of hair were left alone to keep it a relaxed, casual (but still flattering) portrait.

Soft Focus

Another option you can try in portrait optimization is to give the entire image a soft-focus look. This is more of a quick-fix than the detailed approach on the previous pages, but it often works quite well. It's a classic technique, in which a lens filter diffuses the overall image without sacrificing sharp detail. (Vaseline was sometimes smeared on the front of a lens to achieve this effect on-the-fly—something strongly not recommended here.) Note that soft focus is not at all synonymous with unfocused—you must always begin with a sharp shot. The digital method is, of course, more flexible and gives you a greater degree of control regarding exactly how much detail you want to keep in the shot.

↓ Gaussian blur
Begin by making a duplicate layer and applying Gaussian blur—in this case, a 5-pixel radius gives adequate diffusion, but it's a matter of judgement for each individual image.

↑ Blend
Next, set the Blend option for the blurred duplicate layer to Lighten—and for extra control over the adjustment, increase the transparency until the results are to your liking. It doesn't take much to achieve satisfying results, so use a soft touch and keep zooming out to get the big picture at full size.

Retouch a Portrait

↓ ↘ **Take a few years off**
Elderly loved ones don't always photograph so well (we tend to maintain an idealized image in our minds of what those close to us look like—one perpetually healthy and in good spirits), and can often benefit from a simple touch-up.

Portraits are invariably a demanding sort of shot—it's one thing to capture a stunning landscape or a clean architectural shot, but portraits (or, more directly, their subjects) bring their own standards to the table, and it's often expected that at least some amount of post-production work go in to optimizing the shot. And so it's

essential that you begin mastering the essentials of portrait retouching early on, as it's a skill on which you'll build throughout your photographic career. Using the basic tools you've learned in the previous pages, take a portrait of a loved one or friend—someone who will give you an honest appraisal—and go about making it as good as possible.

Basic

White Balance: Custom

Temperature 5150

Tint -11

Brightness 0

Contrast -9

Clarity -21

Vibrance 0

Saturation 0

Challenge Checklist

→ Start with the big-picture, global adjustments and move up from there. Skin tones will be important, so your white balance has to be spot-on.

→ You may have already gotten in certain habits of boosting saturation and contrast—but you'll need to break those habits for portraiture. Even while maintaining your own personal style, you must consider what is flattering to your subject first and foremost.

→ When it comes to localized touch-ups—blemish removal and so on—start on only the most obvious and distracting blemishes, and then take a step back and reevaluate. You don't want to airbrush the personality out of your subject (and this isn't a fashion magazine cover).

↓ **Much more flattering**
This portrait was a very simple retouch job: The magenta color cast was removed by setting a warmer, custom white balance; then the unflatteringly high contrast was lowered, and the lines in her face were de-emphasized by lowering the Clarity in the Raw Processor. Finally, a few distracting blotches on the skin were easily taken out by the Spot Healing Brush, resulting in a much more flattering and comforting shot.

Review

© Dan Goetsch

To even the skin, I used the adjustment brush, increased the brightness, and decreased the clarity. I also selectively sharpened the eyes with a similar technique. Then I converted to black and white and cropped in a bit. While you can use the desaturate option in Photoshop, I also really like to use Nik Silver Efex Pro. It has a lot of options that you can play with makes for a quick workflow. After the conversion I adjusted the brightness and contrast, added in a more attractive crop and called it good.

Dan Goetsch

Skin smoothing is *de rigueur* these days, perhaps even too much, as everyone from *Vogue* to regular portraitists gets in on the act. That is why I like the subtlety in this image, and in particular converting to black and white, which to my mind carries blemish-removal more naturally than does color.

Michael Freeman

© Faith Kashetska-Lefever

For this photo I used a few different tools in Photoshop (creating a new layer for each step). For the shadow effect on her body I used the burn tool at 18% strength, going over a few times until I achieved the look I wanted. I used the brightness and contrast adjustments to make the background pop a little more, and added a little more brightness to her beautiful smile. With the request from the client I used the Liquify tool to take away some of her tummy (although it was not a necessity).
Faith Lefever

Good handling of the skin tone and color, and you rightly identified the smile as very important, so worked to that. I found the use of Liquify amusing, and agree with you—that original curve is very attractive. But, the client has the last say!
Michael Freeman

Hand Coloring

Hand-colored photographs are almost as old as photography itself, but their popularity was at its height during the first half of the 20th century before the advent of Kodak's first color film, when photographers such as Wallace Nutting employed hundreds of colorists to hand paint black-and-white prints of his mostly landscape photographs.

Hand-colored photographs are still popular today because they offer something unique—they create a sense of nostalgia and offer an exceptional method for enhancing a photograph. They also tend to have a large sentimental value to their original owners or subjects, and this technique is often excellent for creating a precious image as a gift.

→ Go for authenticity

Old black-and-white photos often work best for hand coloring as they have a few scratches, blotches, and grain that lend them an authentic look that's hard (or at least tedious) to replicate digitally. This image was shot in the 1960s at a popular British seaside resort. A scan was made and the file opened in the image editor.

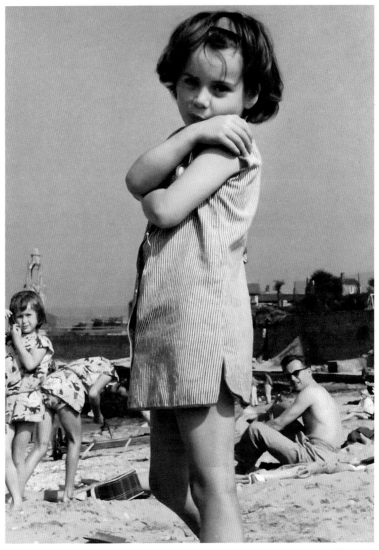

© Steve Luck

← A duplicate layer

First, duplicate the image in the Layers palette. Call the duplicate layer Color and change the blending mode to Color.

Color Picker (Foreground Color)

new

OK

Cancel

Add to Swatches

current

Color Libraries

H:	40	°	L: 76
S:	38	%	a: 8
B:	81	%	b: 33
R:	207		C: 18 %
G:	180		M: 30 %
B:	129		Y: 54 %
#	cfb481		K: 0 %

☐ Only Web Colors

Mode: Normal ⬍ Opacity: 24% ▾ Flow: 15% ▾

↓ Pick a color and start painting

Open the Color Picker dialog and, with a soft round brush, zoom in and start to paint over the photo. Try to ensure an even spread of color, particularly wherever you're adding skin tones.

↑ Careful control

You may find that reducing the Opacity and Flow settings in the Tool Options bar helps you to build up the colors in a more controlled way.

↑ Follow the edges carefully

Adjust the size of the brush to access small areas. As long as you have low Opacity and Flow settings it's less noticeable if you cross from one element to another. If you make an obvious mistake, use the History palette to go back a step.

→ A nostalgic effect

Once you've finished painting, if necessary, reduce the opacity of the Color layer a little in the Layers palette to tone down the colors.

Panoramas

Creating panoramas has never been so straightforward as it is today. In fact, with the sophisticated stitching software that's now available, pretty much the whole process is taken care of automatically once you have the source images.

There are, however, some important rules to remember when shooting panoramas. First, use manual exposure when shooting your source images to ensure consistent exposure throughout the series. Second, it pays to focus

manually, so that the camera doesn't inadvertently autofocus on some close-up object as you're panning round. Finally, to be safe, use the most appropriate white balance preset for the conditions under which you're shooting rather than relying on auto white balance. Again, this ensures consistency. (Yes, this is adjustable as long as you're shooting Raw, but it does simplify the process.) If your camera has a Panorama shooting mode, it may implement these settings on its own
.

Using a tripod will help you ensure the individual source images align, but most of today's software is powerful enough to identify features to create an accurate alignment even if the source images aren't perfectly aligned.

↙↓ Three shots with plenty of overlap

These three images show the Czech capital Prague's historic old town district from the top of Prague's Petřín Lookout Tower (a scaled-down version of the Eiffel Tower). When shooting for a panorama, aim to overlap images by around 40% to give plenty of room to work and line up.

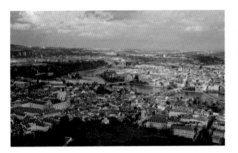 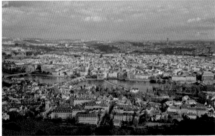 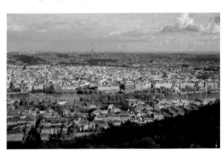

→ Photomerge

After downloading the source files, I launched Photoshop's Photomerge command and browsed to select the images. This particular stitching software offers a number of options: The Layout options provide control if you're creating long panoramas or 360° types. Auto works well in most instances. Select Blend Images Together to create seamless joins between the frames. Vignette Removal helps ensure a smoothly toned sky. Use Geometric Distortion Correction only to counteract noticeable barrel or pin-cushion distortion.

Photomerge

Layout
- ⦿ Auto
- ○ Perspective
- ○ Cylindrical
- ○ Spherical
- ○ Collage
- ○ Reposition

Source Files
Use: Files
IMG_2257.JPG
IMG_2258.JPG
IMG_2259.JPG

Browse...
Remove
Add Open files

OK
Cancel

☑ Blend Images Together
☐ Vignette Removal
☐ Geometric Distortion Correction

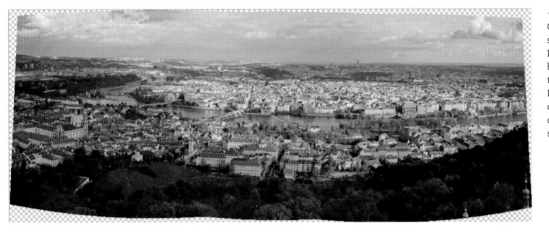

← Stitch them together

Once you've made the various selections, click OK, and then Photomerge will automatically blend the images together to create the panorama. Here, I used the Auto layout option, which produces the optimal result based on the source files.

→ Crop out the edges

Look for any obvious misalignments or poor tonal mismatch in areas of flat color. If this occurs you may need to consider using alternative layout options and the Vignette Removal control. When you're happy, flatten the image and crop out any white space.

↓ Final adjustments

After you've cropped out the white space you can fine-tune the overall tone, color saturation, sharpening, and so on before saving the final panorama.

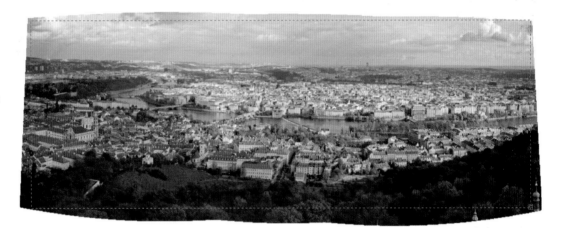

© Steve Luck

Stitch a Panorama

Sometimes the world just can't fit into a single frame. And sometimes you want to get as much resolution as you can of a particular scene. Whatever your motivation, a panorama is an essential tool in your photographic repertoire, and once you work through this challenge, you'll be surprised just how easy they are to achieve. The first step is choosing an appropriate subject—typically we think of horizontally wide ones, but vertical panoramas are just as valid. Step two is getting plenty of shots to work with, followed by step three: the stitching. You may have some special effect possibilities built into the stitching software, so feel free to play around and see what your various options are.

↓←↑ Pre-pano adjustments
This series of shots all needed some slight color adjustments, so they were synchronized in Adobe Camera Raw and adjusted first, before then being ported into Photoshop's Photomerge function via Adobe Bridge.

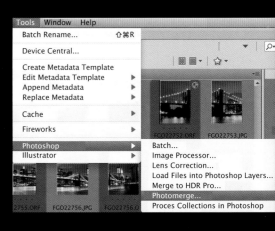

↑↓→ Crop to fit your output

The image sequence is moved to Photoshop and arranged as a series of overlapping layers. The next step is, of course, to crop rectangle with clean edges out of the roughly stitched full image. At this stage, you must consider your output. Few display options exist for extremely wide images, so while this could be cropped considerably wider, a 16:9 (common HD) aspect ratio was chosen.

Challenge Checklist

→ While a tripod is always a useful tool, don't let the lack of one prevent you from attempting a series of shots while you're out in the field. Just get plenty of overlap between each shot, so your stitching program has a better chance at lining things up afterward.

→ Manual exposure mode is a definite requirement. You don't want to be making painstaking adjustments to each image, trying to equalize the exposure across the series. Besides, any slight different will be readily viewable along the joins.

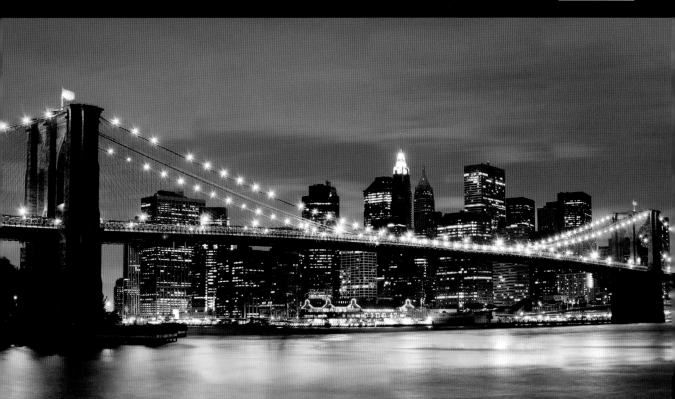

Review

© Dan Goetsch

The sun was going down quick and I didn't want to miss my chance with the great light. I pulled my car off to the side of the road and hiked down an embankment. I took 5 shots to fit the entirety of the lake into one shot. In Photoshop I used the Photomerge script to create the panorama. Once that was done I used the Lens Correction filter to remove some of the lens distortion from using my wide-angle lens. I also cropped the image to get rid of the uneven parts created while merging the photos. From there I wanted to bring back some of the warm sunset tones that I saw when I was there, so I adjusted the saturation, vibrance, and contrast.

Dan Goetsch

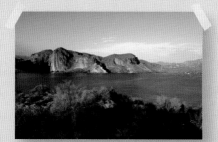

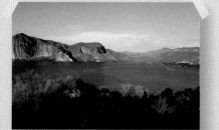

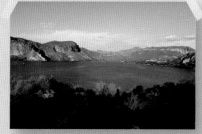

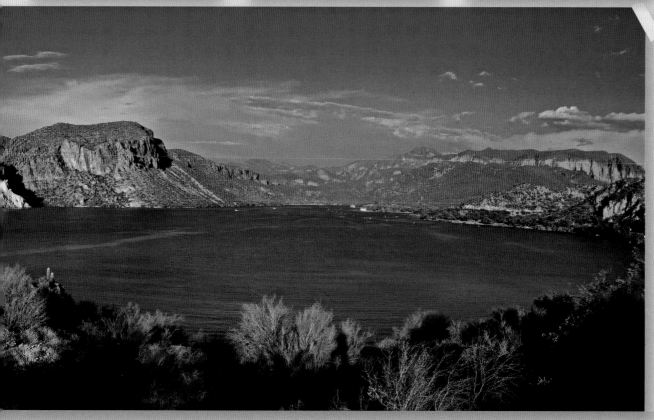

Excellent! You shot for the essential horizontality of the scene, including the capping of the hills by cloud, and a panoramic stitch does it real justice. Nice closure at the right. I can see that you guaranteed the shot by overlapping more than was probably needed for the stitch—which was the professional thing to do.

Michael Freeman

HDR Imagery

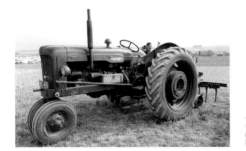

Metered exposure

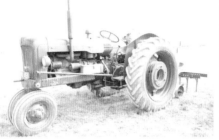

+2 EV

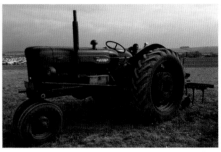

-2 EV

The concept behind HDR (high dynamic range) imagery is a simple one. If the brightness range of the scene you're photographing exceeds the range that the camera's sensor can capture with one exposure, then take a series of exposures—the standard metered exposure, plus additional ones to capture the highlights and/or shadows that are outside the range of the sensor—and combine them to create a single image that shows the complete brightness range.

As well as combining the images to create a 32-bit genuine HDR file (which can't be viewed accurately on-screen as most monitors lack the requisite dynamic range), what HDR software will also do is apply localized tone mapping. This ensures brightness levels are set according to localized areas of the image rather than globally across the entire image. In this way, shadow areas can be opened up without the risk of causing highlight areas to overexpose. The tone-mapped image can be saved either as a 16- or 8-bit file, which can then be viewed or printed to give the appearance of the true 32-bit HDR image.

It's the tone mapping algorithms that create the "HDR look," and setting the strength of the tone mapping algorithm is one of the key ways to determine how realistic (or surrealistic) the HDR image appears.

↖↑ **A three-shot bracket**
The three source images of this vintage tractor adequately cover the entire dynamic range of the original scene.

↑ **Dealing with motion**
One of the main issues when processing an exposure sequence for HDR is how to deal with any moving elements, such as cars and people. Any moving object will appear in slightly different places across the frames, creating a blurred, ghostlike effect—as here with the man's head above the back tire. Different HDR programs cope with ghosting in different ways. Photomatix, one of the more popular programs, has an efficient de-ghosting routine in which you can encircle the affected area and select the single frame you wish to use as the main option. Using just one frame naturally overcomes the issue.

↑ Consider the presets

Most programs offer a variety of preset options as starting points for tone mapping your image. How useful these are varies from program to program. Photomatix has some usable presets that work well. Simply click on a preset option for the relevant adjustments.

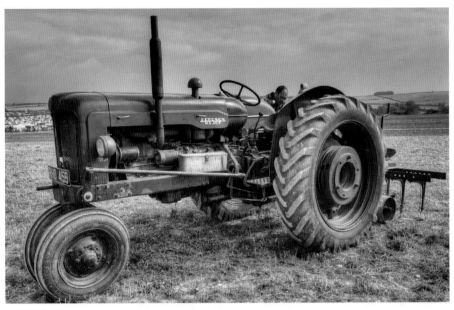

↑ Tone-mapping controls

Having created the full 32-bit HDR image, you will be presented with an adjustment toolbar. All HDR software will have the principal controls along the lines shown here, such as Strength, Color Saturation, Luminosity, and so on. Photomatix has additional options unique to its algorithms, just as other programs will also have their own unique controls.

↗→ Real vs. surreal

Most HDR programs are now sufficiently versatile to create a wide range of HDR styles, from the photorealistic (shown above) to the surrealistic (shown right) and plenty of space in between.

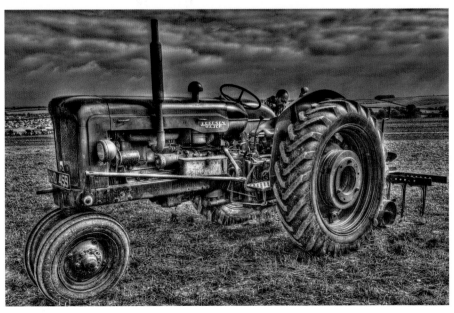

Create a High Dynamic Range Image

↓ Detailed shadows

This shot is a classic example of naturalistic HDR. If the camera's sensor had just a touch more DR capability, multiple shots wouldn't even be needed. But as it is, the multiple exposures (just one for the shadows and one for the golden snow), capture an even amount of detail throughout this picturesque scene, letting the light speak for itself.

Your HDR image can be of pretty much any subject imaginable, but it's particularly suited for subjects in challenging lighting conditions that couldn't otherwise be captured in a single shot. Think about backlit scenarios or interior scenes with windows opening onto bright sunlight outdoors.

Once you pick your subject, you'll then need to decide how to render your final image. Do you want to just barely use the software to capture bright highlights, leaving a naturalistic photo? Or do you want to do over the edge and really extract as much detail as possible, creating an otherworldly, surrealistic masterpiece? (You'll often want to be somewhere in between.)

© Jarosław Grudziński

Challenge Checklist

→ While it's technically feasible to turn any sequence into an HDR image, you'll be most rewarded if you can find a subject that needs and can make the most use of that expanded dynamic range.

→ People tend to have strong opinions about HDR, but you should allow yourself the chance to explore its full potential before making any judgement yourself. There are any number of ways HDR can be incorporated into your workflow, so keep an open mind.

→ Bring along a tripod. Even if your HDR software has an alignment feature, it's likely to not be perfect, and anything less than perfection results in the halos that are a trademark of overworked HDR photography.

↑ Irradiated rocks

As compared to the page opposite, this image goes completely in the other direction. The multiple images are stacked together to extract enormous amount of texture and detail from the rocky foreground and distant sky, and the colors are heavily saturated, resulting in a photo that packs a punch.

Review

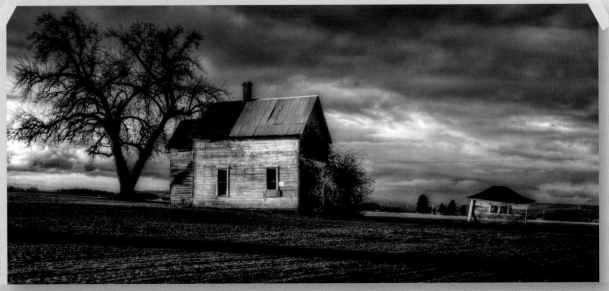

© Dan Goetsch

This image is a composite of 4 pictures smashed into one. It works great because I wanted to bring out the detail in the clouds and sky while preserving the detail in the farm and field. When creating an HDR, I usually leave the sliders alone to avoid creating something too crazy. I primarily adjust the gamma settings and make sure the shadows/highlights look correct. From there, I bring it into Photoshop and adjust brightness, contrast, sharpening, saturation/vibrance, and crop.
Daniel Goetsch

I'm really not a fan of hyper-ventilated HDR tone mapping, so you won't be surprised that I react pleasurably to this treatment. It's slightly amped up, but it works, with a rich and seething sky. It probably accords more with what you saw than a single-sensor capture could record.
Michael Freeman

© Guido Jeurissen

This night shot combined three photos, shot at 10, 20, and 30 seconds. I used Photoshop to merge them into an HDR, and then used Lightroom to change the colors and add a bit of contrast.
Guido Jeurissen

Another good use of HDR (I was fearing the worst from these pages). The originals are flat, and while you haven't used a particularly wide capture range—less than 3 f-stops— the processing is enough to breathe life into the scene without going over the top.
Michael Freeman

Glossary

additive primary colors The three colors red, blue, and green, which can be combined to create any other color. When superimposed on each other they produce white.

algorithm Mathematical procedure that allows the step-by-step solution of a problem.

aliasing The jagged appearance of diagonal lines in an image, caused by the square shape of pixels.

anti-aliasing The smoothing of jagged edges on diagonal lines created in an imaging program, by giving intermediate values to pixels between the steps.

application (program) Software designed to make the computer perform a specific task. So, image-editing is an application, as is word-processing. System software, however, is not an application, as it controls the running of the computer.

artifact A flaw in a digital image.

aspect ratio The ratio of the height to the width of an image, screen, or page.

backup A copy of either a file or a program, for safety reasons, in case the original becomes damaged or lost. The correct procedure for making backups is on a regular basis, while spending less time making each one than it would take to redo the work lost.

banding Unwanted effect in a tone or color gradient in which bands appear instead of a smooth transition. It can be corrected by higher resolution and more steps, and by adding noise to confuse that part of the image.

Bézier curve A curve described by a mathematical formula. In practice, it is produced by manipulating control handles on a line that is partly held in place by anchor points.

bit (binary digit) The basic data unit of binary computing. *See also* byte

bit depth The number of bits-per-pixel (usually per channel, sometimes for all the channels combined), which determines the number of colors it can display. Eight bits-per-channel are needed for photographic-quality imaging.

bitmap (bitmapped image) Image composed of a pattern of pixels, as opposed to a mathematically defined object (an object-oriented image). The more pixels used for one image, the higher its resolution. This is the normal form of a scanned photograph.

BMP Image file format for bitmapped images used in Windows. Supports RGB, indexed color, grayscale and bitmap.

brightness The level of light intensity. One of the three dimensions of color. *See also* hue *and* saturation

buffer An area of temporary data storage, normally used to absorb differences in the speed of operation between devices. For instance, a file can usually be sent to an output device, such as a printer, faster than that device can work. A buffer stores the data so that the main program can continue operating.

byte Eight bits—the basic data unit of desktop computing. *See also* bit

cache An area of information storage set aside to keep frequently needed data readily available. This allocation speeds up operation.

calibration The process of adjusting a device, such as a monitor, so that it works consistently with others, such as scanners and film recorders.

CGI (Computer-Generated Image) Electronic image created in the computer (as opposed to one that has been transferred from another medium, such as a photograph).

channel Part of an image as stored in the computer; similar to a layer. Commonly, a color image will have a channel allocated to each primary or process color, and sometimes one or more for a mask or other effect.

clipboard Part of the memory used to store an item temporarily when being copied or moved. *See also* cut-and-paste

cloning In an image-editing program, the process of duplicating pixels from one part of an image to another.

CMYK (Cyan, Magenta, Yellow, Key) The four process colors used for printing, including black (key).

color depth *See* bit depth

color gamut The range of color that can be produced by an output device, such as a printer, a monitor, or a film recorder.

color model A system for describing the color gamut, such as RGB, CMYK, HSB, and lab.

color separation The process of separating an image into the process colors cyan, magenta, yellow, and black (CMYK), in preparation for printing.

color space A model for plotting the hue, brightness, and saturation of color.

compression Technique for reducing the amount of space that a file occupies, by removing redundant data.

contrast The range of tones across an image from highlight to shadow.

CPU (Central Processing Unit) The processing and control center of a computer.

cropping Delimiting an area of an image.

cursor Symbol with which the user selects and draws on-screen.

cut-and-paste Procedure in graphics for deleting part of one image and copying it into another.

default The standard setting or action used by a computer unless deliberately changed by the operator.

desktop The background area of the computer screen on which icons and windows appear.

desktop computer Computer small enough to fit on a normal desk. The two most common types are the PC and Macintosh.

dialog box An on-screen window, part of a program, for entering settings to complete a procedure.

digital A way of representing data as a number of distinct units. A digital image needs a very large number of units so that

it appears as a continuous-tone image to the eye; when it is displayed these are in the form of pixels.

digital zoom A false zoom effect used in some cheaper digital cameras; information from the center of the CCD is enlarged with interpolation.

download Sending a data file from the computer to another device, such as a printer. More commonly, this has come to mean taking a file from the Internet or remote server and putting it onto the desktop computer. *See also* upload

dpi (dots-per-inch) A measure of resolution in halftone printing. *See also* ppi

drag Moving an icon or a selected image across the screen, normally by moving the mouse while keeping its button pressed.

drag-and-drop Moving an icon from one file to another by means of dragging and then dropping it at its destination by releasing the mouse button. *See also* drag

dynamic range The range of tones that an imaging device can distinguish, measured as the difference between its dmin and dmax. It is affected by the sensitivity of the hardware and by the bit depth.

fade-out The extent of any graduated effect, such as blur or feather. With an airbrush tool, for example, the fade-out is the softness of the edges as you spray.

file format The method of writing and storing a digital image. Formats commonly used for photographs include tiff, pict, bmp, and jpeg (the latter is also a means of compression).

filter Imaging software included in an image-editing program that alters some image quality of a selected area. Some filters, such as Diffuse, produce the same effect as the optical filters used in photography after which they are named; others create effects unique to electronic imaging.

gamma A measure of the contrast of an image, expressed as the steepness of the characteristic curve of an image.

GB (GigaByte) Approximately one billion bytes (actually 1,073,741,824).

global correction Color correction applied to the entire image.

grayscale A sequential series of tones, between black and white.

GUI (Graphic User Interface) Screen display that uses icons and other graphic means to simplify using a computer. The Macintosh GUI was one of the reasons for Apple's original success in desktop computing.

hard disk, hard drive A sealed storage unit composed of one or more rigid disks that are coated with a magnetically sensitive surface, with the heads needed to read them. This can be installed inside the computer's housing (internal), or in a separate unit linked by a bus (external).

HDRi (High Dynamic Range imaging) Software-based process that combines a number of images taken at different exposure settings to produce an image with full shadow to highlight detail.

histogram A map of the distribution of tones in an image, arranged as a graph. The horizontal axis is in 256 steps from solid to empty, and the vertical axis is the number of pixels.

HSB (Hue, Saturation and Brightness) The three dimensions of color. One kind of color model.

hue A color defined by its spectral position; what is generally meant by "color" in lay terms.

icon A symbol that appears on-screen to represent a tool, file, or some other unit of software.

image compression A digital procedure in which the file size of an image is reduced by discarding less important data.

image-editing program Software that makes it possible to enhance and alter a scanned image.

image file format The form in which an image is handled and stored electronically. There are many such formats, each developed by different manufacturers and with different advantages according to the type of image and how it is intended to be used. Some are more suitable than others for high-resolution images, or for object-oriented images, and so on.

interface Circuit that enables two hardware devices to communicate. Also used for the screen display that allows the user to communicate with the computer. *See also* GUI

interpolation Bitmapping procedure used in resizing an image to maintain resolution. When the number of pixels is increased, interpolation fills in the gaps by comparing the values of adjacent pixels.

JPEG (Joint Photographic Experts Group) Pronounced "jay-peg," a system for compressing images, developed as an industry standard by the International Standards Organization. Compression ratios are typically between 10:1 and 20:1, although lossy (but not necessarily noticeable to the eye).

KB (KiloByte) Approximately one thousand bytes (actually 1,024).

lasso A selection tool used to draw an outline around an area of the image.

layer One level of an image file, separate from the rest, allowing different elements to be edited separately.

LCD (Liquid Crystal Display) Flat screen display used in digital cameras and some monitors. A liquid-crystal solution held between two clear polarizing sheets is subject to an electrical current, which alters the alignment of the crystals so that they either pass or block the light.

lossless Type of image compression in which no information is lost, and so most effective in images that have consistent areas of color and tone. For this reason, not so useful with a typical photograph.

lossy Type of image compression that involves loss of data, and therefore of image quality. The more compressed the image, the greater the loss.

luminosity Brightness of color. This does not affect the hue or color saturation.

macro A single command, usually a combination of keystrokes, that sets in motion a string of operations. Used for convenience when the operations are run frequently.

mask A grayscale template that hides part of an image. One of the most important tools in editing an image, it is used to make changes to a limited area. A mask is created by using one of the several selection tools in an image-editing program; these isolate a picture element from its surroundings, and this selection can then be moved or altered independently.

MB (MegaByte) Approximately one million bytes (actually 1,048,576).

menu An on-screen list of choices available to the user.

midtone The parts of an image that are approximately average in tone, midway between the highlights and shadows.

mode One of a number of alternative operating conditions for a program. For instance, in an image-editing program, color and grayscale are two possible modes.

noise Random pattern of small spots on a digital image that are generally unwanted, caused by non-image-forming electrical signals.

object-oriented (image, program) Software technology using mathematical equations rather than pixels to describe an image element. Scalable, in contrast to bitmapped elements.

paste Placing a copied image or digital element into an open file. In image-editing programs, this normally takes place in a new layer.

PDF (Portable Document Format) An industry standard file type for page layouts including images. Can be compressed for Internet viewing or retain full press quality; in either case the software to view the files—Adobe Reader—is free.

peripheral An additional hardware device connected to and operated by the computer, such as a drive or printer.

photo-composition The traditional, non-electronic method of combining different picture elements into a single, new image, generally using physical film masks.

pixel (PICture ELement) The smallest unit of a digitized image—the square screen dots that make up a bitmapped picture. Each pixel carries a specific tone and color.

plug-in module Software produced by a third party and intended to supplement a program's performance.

ppi (pixels-per-inch) A measure of resolution for a bitmapped image.

processor A silicon chip containing millions of micro-switches, designed for performing specific functions in a computer or digital camera.

program A list of coded instructions that makes the computer perform a specific task. *See also* software

real-time The appearance of instant reaction on the screen to the commands that the user makes—that is, no appreciable time-lag in operations. This is particularly important when carrying out bitmap image-editing, such as when using a paint or clone tool.

resampling Changing the resolution of an image either by removing pixels (lowering resolution) or adding them by interpolation (increasing resolution).

resolution The level of detail in an image, measured in pixels (e.g. 1024 by 768 pixels), lines-per-inch (on a monitor) or dots-per-inch (in the halftone pattern produced by a printer, e.g. 1200 dpi).

RGB (Red, Green, Blue) The primary colors of the additive model, used in monitors and image-editing programs.

rubber-stamp A paint tool in an image-editing program that is used to clone one selected area of the picture onto another. It allows painting with a texture rather than a single tone/color, and is particularly useful for extending complex textures such as vegetation, stone, and brickwork.

saturation The purity of a color; absence of gray, muddied tones.

selection A part of the on-screen image that is chosen and defined by a border, in preparation for making changes to it or moving it.

SLR (Single Lens Reflex) A camera which transmits the same image via a mirror to the film and viewfinder.

software Programs that enable a computer to perform tasks, from its operating system to job-specific applications such as image-editing programs and third-party filters.

stylus Penlike device used for drawing and selecting, instead of a mouse. Used with a graphics tablet.

thumbnail Miniature on-screen representation of an image file.

TIFF (Tagged Image File Format) A file format for bitmapped images. It supports CMYK, RGB, and grayscale files with alpha channels, and lab, indexed-color, and it can use LZW lossless compression. It is now the most widely used standard for good-resolution digital photographic images.

tool A program specifically designed to produce a particular effect on-screen, activated by choosing an icon and using it as the cursor. In image-editing, many tools are the equivalents of traditional graphic ones, such as a paintbrush, pencil, or airbrush.

toolbox A set of programs available for the computer user, called tools, each of which creates a particular on-screen effect. *See also* tool

trackball An alternative input device to a mouse, used to move the cursor on-screen. Mechanically, it works as an upside-down mouse, with a ball embedded in a case or the keyboard.

upgrade Either a new version of a program or an enhancement of hardware by addition.

upload To send computer files, images, etc. to another computer. *See also* download

USB (Universal Serial Bus) In recent years this has become the standard interface for attaching devices to the computer, from mice and keyboards to printers and cameras. It allows "hot-swapping," in that devices can be plugged and unplugged while the computer is still switched on.

USM (Unsharp Mask) A sharpening technique achieved by combining a slightly blurred negative version of an image with its original positive.

virtual memory The use of free space on a hard drive to act as temporary (but slow-to-access) memory.

WiFi A wireless connectivity standard, commonly used to connect computers to the Internet via a wireless modem or router.

workstation A computer, monitor, and its peripherals dedicated to a single use.

Index

Bibliography & Useful Addresses

Books

The Complete Guide to Light and Lighting in Digital Photography
Michael Freeman

The Photoshop Pro Photography Handbook
Chris Weston

Perfect Exposure
Michael Freeman

Mastering High Dynamic Range Photography
Michael Freeman

Pro Photographer's D-SLR Handbook
Michael Freeman

The Complete Guide to Black & White Digital Photography
Michael Freeman

The Complete Guide to Night & Lowlight Photography
Michael Freeman

The Art of Printing Photos on Your Epson Printer
Michael Freeman & John Beardsworth

Digital Photographer's Guide to Adobe Photoshop Lightroom
John Beardsworth

The Photographer's Eye
Michael Freeman

The Photographer's Mind
Michael Freeman

Websites

Note that website addresses may often change, and sites appear and disappear with alarming regularity. Use a search engine to help find new arrivals.

Photoshop sites

Absolute Cross Tutorials
www.absolutecross.com

Laurie McCanna's Photoshop Tips
www.mccannas.com

Planet Photoshop
www.planetphotoshop.com

Photoshop Today
www.designertoday.com

ePHOTOzine
www.ephotozine.com

Digital imaging and photography sites

Creativepro
www.creativepro.com

Digital Photography
www.digital-photography.org

Digital Photography Review
www.dpreview.com

Short Courses
www.shortcourses.com

Software

Alien Skin
www.alienskin.com

ddisoftware
www.ddisoftware.com

DxO
www.dxo.com

FDRTools
www.fdrtools.com

Photoshop, Photoshop Elements
www.adobe.com

PaintShop Photo Pro
www.corel.com

Photomatix Pro
www.hdrsoft.com

Toast Titanium
www.roxio.com

Useful Addresses

Adobe www.adobe.com

Apple Computer www.apple.com

BumbleJax www.bumblejax.com

Canon www.canon.com

Capture One Pro www.phaseone.com/en/Software/

Capture-One-Pro-6 Corel www.corel.com

Epson www.epson.com

Expression Media www.phaseone.com/expressionmedia2

Extensis www.extensis.com

Fujifilm www.fujifilm.com

Hasselblad www.hasselblad.se

Hewlett-Packard www.hp.com

Iomega www.iomega.com

Kodak www.kodak.com

LaCie www.lacie.com

Lightroom www.adobe.com

Microsoft www.microsoft.com

Nikon www.nikon.com

Olympus www.olympusamerica.com

Pantone www.pantone.com

Philips www.philips.com

Photo Mechanic www.camerabits.com

PhotoZoom www.benvista.com

Polaroid www.polaroid.com

Ricoh www.ricoh-europe.com

Samsung www.samsung.com

Sanyo www.sanyo.co.jp

Sony www.sony.com

Symantec www.symantec.com

Wacom www.wacom.com